THE GENESIS OF A PAINTING

THE GENESIS OF A
PAINTING
PICASSO'S GUERNICA

BY RUDOLF ARNHEIM

UNIVERSITY OF CALIFORNIA PRESS

Berkeley, Los Angeles, London

UNIVERSITY OF CALIFORNIA PRESS
BERKELEY AND LOS ANGELES, CALIFORNIA

UNIVERSITY OF CALIFORNIA PRESS, LTD.
LONDON, ENGLAND

CONTENTS

I NOTES ON CREATIVITY

The human mind is not easily accessible. Nobody ever comes to know more than one specimen of mind directly—that is, without a go-between; and this one specimen, the person's own mind, tends to shrink when it is watched. Wishing to spy on oneself, one gets into the "critical situation" described by Kant in his *Anthropology*. "When the psychical powers are in action," he says, "one does not observe oneself; and when one observes oneself, those powers stop."

Nor is it easier to observe others. Kant continues to say: "A person noticing that someone is watching him and is trying to explore him will either become embarrassed, in which case he *cannot* show himself as he is; or he will disguise himself, in which case he does not *want* to be recognized for what he is." This dilemma, inherent in psychology, is all the more serious when the mental processes to be scrutinized rely upon impulses issuing from beyond the realm of awareness. Those impulses are often deranged or entirely blocked when their coming and going are watched. Paul Valéry, addressing a congress of surgeons in 1944, went so far as to suggest that the vital importance of a mental function can be measured by the degree to which that function is intolerant of attentive consciousness. "In other words, there are functions that prefer the shadow to the light, or at least the twilight—that is, that minimum of conscious awareness which is necessary and sufficient to make these acts come about or to bait them. If failure or blocking is to be avoided, the cycle of sensation and motor activity must take its course without observations or interruptions, from its origin to the physiological limit of the performed act. This jealousy, this kind of modesty of our automatisms, is quite remarkable. One could derive a complete philosophy from it, which I would summarize by saying: Sometimes I think, and sometimes I am."

Artists, in particular, have learned to tread cautiously when it comes to reporting the internal events that produce their works. They watch with suspicion all attempts to invade the inner workshop and to systematize its secrets. Surely, creative processes are not the only ones to rely upon impulses from outside the realm of awareness, but they are unique in that their results give the impression of being beyond and

above what can be accounted for by the familiar mental mechanisms. To the artist himself, his accomplishment is often a cause of surprise and admiration, a gift from somewhere rather than the traceable outcome of his efforts. It is viewed as a privilege that might be forfeited like the golden treasures of the fairy tales, which vanish when curiosity ignores the warnings and peeps at the miracle-working spirit.

The privilege and the nuisance of relying on helpers who do not take orders require those abnormalities of behavior for which artists have been known: those fears of power failure, those irritations and despairs, the agonies of waiting, the manic delights of success, the elaborate rituals necessary to create propitious conditions. The gift of divination, says Plato in the *Timæus*, is granted by God not to the wisdom but to the foolishness of man. "No man, when in his wits, attains prophetic truth and inspiration; but when he receives the inspired word, either his intelligence is enthralled in sleep, or he is demented by some distemper or possession." In the *Phædrus* he explains that not by accident are prophecy and madness referred to by the same word, *maniké*; and together with prophecy he mentions "the madness of those who are possessed by the Muses; which taking hold of a delicate and virgin soul, and there inspiring frenzy, awakens lyrical and other numbers; with these adorning the myriad actions of ancient heroes for the instruction of posterity. But he who, having no touch of the Muses' madness in his soul, comes to the door and thinks that he will get into the temple by the help of art—he, I say, and his poetry are not admitted; the sane man disappears . . ."

Since what man calls his self are the functions controlled by him, the creative powers beyond man's control were naturally thought of as originating outside the self. Hence the notion that poetical madness was a gift of the Muses; hence also the practice of invocation by which the poet—from Homer through the ages to Dante—endeavored to assure superhuman assistance. The mortal creator asked for inspiration, a term derived in our Western tradition from the breath of life which God breathed into the first man's nostrils, thus making him become a living soul after forming him of the dust of the ground (". . . et inspiravit in faciem ejus spiraculum vitæ, et factus est homo in animam viventem").

I cannot here retrace the steps of the development by which *enthousiasmos*, the state of being possessed by divine power, was gradually redefined as a possession by inside forces, they too independent of the controlling self and operating below the level of awareness. Dante, while invoking the muses, was already calling also upon his own "high genius" (*alto ingegno*) and upon his "mind" (*mente*), which recorded what the poet saw, as though they were allies rather than his own capacities. But only the romantic movement formally introduced the decisive shift that so profoundly affected our modern thinking and according to which inspiration no longer comes from the outside but from the inside, not from above but from below.

There is another aspect of the creative process, less fashionable today but equally fundamental and equally rooted in the history of our culture. The madness of which

Plato spoke seems to have been reserved by him for the poets, who moved in the exalted company of the philosophers and the musicians. We do not find it attributed to the painters and sculptors, of whom he thought as craftsmen. What was the task of the craftsman, the *technítes*? If we may rely on Martin Heidegger, *téchne* was considered a form of cognition—that is, of perceiving what exists. Thus, the craftsman had to make existence visible. He did this by giving shape to the functions of life, by shaping pots and tables and shoes and also by painting, carving, or modeling images.

The rules of how to fashion correct images were derived from mathematics, which formulated the secrets of the cosmos. Thus in Greece as well as, for example, in Egypt, artists formed the human figure according to traditional canons of measurable proportion—a practice that prevailed through the ages and survives even in our day. As far as painters and sculptors were concerned, the creative process was expected to take place in the full sunlight of reason. In order to avoid misunderstandings, we must here remember that the poets too received eventually their full share of rationality, which first entered their field via the mathematical canons of musical composition. However, by the time of the romantic movement, the painters and sculptors had parted company with the craftsmen, and the musicians had abandoned the mathematicians; and both art and music had joined poetry in claiming the privilege of being created by irrational procedures—procedures which not only can do without the help of the intellect and its prescriptions but are threatened by it. Around the middle of the nineteenth century Balzac, in his story "The Unknown Masterpiece," symbolized the irrationality of art by inventing the character of the mad painter Frenhofer, whose supreme effort produces a picture in which others see nothing but "confusedly amassed colors, contained by a multitude of bizarre lines, which amount to a wall of paint." At about the same time, in his opera *Die Meistersinger von Nürnberg*, Richard Wagner repudiated the traditional rules of musical composition in the figure of the pedantic Beckmesser.

Curiously, the advent of depth psychology led to a continuation of both traditions. Romantic thinkers welcomed it as the scientific confirmation of their belief that creativity originates in unfathomable profundities, which no explorer should attempt to probe. To a psychologist of Freud's cast of mind, however, the alleged irrationality of the creative process was a challenge rather than a deterrent. In fact, his great distinction was that he took the axiom of psychological determinism seriously and assumed therefore that any mental process, submerged, erratic, and incalculable though it may seem, must be subject to general laws of functioning. It was this trust in the ultimate rationality of the apparently irrational that led him to describe concretely some of the mechanisms of creativity for the first time.

The extension of deterministic thinking from the physical sciences to psychology derived some of its courage from what may be called the democratization or secularization of the human mind: the notion that just as every citizen, even the genius, is subject to the laws of the state, there can be no exceptions to the laws governing the

activities of the mind. Thus the unusual had to be understood as a special instance of the usual, and the accomplishment of the genius was different only in degree from what slept or simmered or vegetated in the mind of the common man. Creativity came to be thought of as the possession and privilege of every human being, and modern education became a technique for developing this most precious common property.

Thus creativity entered the domain of academic psychology. It was dealt with mostly by common-sense speculation when the psychologist, or his untrained equivalent, was called upon to supply a more scientific foundation for the understanding of the most distinguished human capacity. The creative process was also subjected to experiment, and it is fair to admit that until now common sense and experiment have yielded the same kind of result. For example, an experimental psychologist, Catharine Patrick, confirmed the assertion of an earlier writer, Graham Wallas, according to which the creative process is made up of four orderly stages: preparation, incubation, illumination, and verification. She arrived at her conclusions by asking a number of poets and laymen to write a poem about the picture of a landscape she showed them and to talk aloud while they were working. The poet Cecil Day Lewis, in his book *The Poetic Image*, speaks of three such stages: images or ideas, flow of association, and critical judgment. Similar sensible schemes are given in studies by other authors. In addition, the psychological equipment to be found in creative persons has been investigated by means of tests. J. P. Guilford, for example, reports that the creative individual possesses fluency, flexibility, and originality—that is, much material must be readily accessible to him, he must be flexible in his procedures, and he must avoid the conventional.

The most influential speculations on this subject are of course those by Freud and Jung. For the present purpose, it suffices to remember that for Freud creativity was a refinement of biological productivity, not only in the sense that art and science were to have developed from the desire to satisfy basic instincts, but also, and more radically, in that the ultimate motive of any artistic or scientific effort continued to be that same desire. There was also an implication that those ultimate motives were something to be ashamed of, since the orientations and procedures that distinguished the work of creative man from the straight consummations of biological man were supposed not only to replace these consummations when they were unavailable but also to hide or adorn the ultimate purpose. This meant that any endeavor to represent and interpret human existence was thought of as being at the service of sex and aggressiveness and therefore necessarily distorted by the particular interests of these drives. It also meant that the devices of artistic form were not intended "to make visible what exists" but to conceal what they were being used for.

Whereas according to Freud the original impulse of creativity was motivational, it was cognitive for Jung; that is, Freud believed that art and science came into being because basic instincts needed to be satisfied, either directly or indirectly, but Jung

saw the beginning of man's symbolic activity in dispositions for certain basic images, given to every human being by heredity and embodying the quintessence of the wisdom of the ages. It was from these archetypes that the more particular forms created by the thinker and the artist were to have derived. Regardless of whether or not the theory of the archetypes will ever be substantiated, it served to draw renewed attention to certain universal concepts of thought and imagery. It also helped to re-establish the conviction that man's concern with his existence is not reducible to the biology of procreation or attack. At the same time, however, the doctrine of the archetypes threatened to standardize the basic contents of the human imagination; and the letdown experienced when, for example, the inventions of a Leonardo da Vinci or a Henry Moore were reduced to representations of the primordial mother or earth goddess was hardly less painful than being left with nothing but the Freudian instincts.

Indubitably, powerful personal impulses must have contributed to Picasso's concept of *Guernica*. A psychologically oriented biography of the painter would profit from any well-supported inferences derivable from his work. Also, some aspects of the mural itself might be clarified if we knew more certainly their personal connotations in the mind of the artist. This, it will be seen, is especially true for the figure of the bull. But I hope to be able to show that even a thorough acquaintance with the artist's intimate strivings would not help us to understand what is essential about *Guernica*, since the picture is not a statement about Picasso but about the condition of the world; just as Dante's biography will not make us appreciate Beatrice's role and function in the *Commedia*. Similarly, it is true that if we knew a great deal about the meaning which such images as the bull or the horse may have in the minds of men throughout the ages, we could place Picasso's work into a larger context. However, it remains doubtful whether by enlarging our investigation to the extent of giving it the scope of a mythological case study we would learn more about *Guernica* in particular than we would by narrowing it to an exploration of the painter's private motives.

All depth psychology of whatever school or shade insists on the importance of unconscious processes in creativity, and there is no question that most of the decisive impulses of the artist—and, indeed, of the scientist—issue, as I mentioned earlier, from below the threshold of awareness. This is true, however, for most human activities. In weighty as well as in small matters we commonly judge and decide on the basis of criteria which we identify only *post factum* and on request, if at all, and which, more often than not, can be formulated in sensible speech only with difficulty. At the same time we feel quite sure that we did not act arbitrarily or blindly but for good reasons. Even for the execution of our decisions we tend to dispense with awareness when taking care of routine matters. We "tune in" only when an uncommon turn of events requires special attention. So smoothly do we oscillate between witting and unwitting behavior that much of the time we do not remember

5

whether or not an action was accompanied with awareness. This is possible because for many practical purposes we function at least as well without the help of awareness as we do with it and because all the mental capacities of perceiving, remembering, reacting, and reasoning operate regardless of whether or not we watch their doings. In a certain sense, then, it is true that in the creative process conscious behavior and unconscious behavior are no more different from each other than the flowing of a river in full daylight is different from its flowing in the darkness of night.

Originally, the term "unconscious" designated nothing more than an attribute applicable to any mental act, indicating simply that the act takes place without awareness. Under the influence of psychoanalysis, however, the term came to mean a particular place in what might be called a metaphorical geography of the mind. "Unconscious" was promoted from adjective to noun, and ended as the name of a special mental power, which behaved according to the tenets of one or another school of thought. On a sliding scale ranging from the most unconscious to the most conscious level, mental processes were distinguished by the degree to which they were deep or shallow, available or unavailable, strong or weak, free or rigid, rational or irrational, beastly or wise, ancient or late.

Some kinds of process seem to change character when they become conscious. Some are unconscious by their very nature, and show up in awareness only through their effects. Interest has centered in particular on the primitive quality of certain ways of functioning which prosper below the level of awareness and which are variously described as beastly or wise. There is actually no contradiction in what these two contradictory terms are meant to describe. They point to the animal-like freedom from moral restrictions, granted subterraneously to man's most elementary strivings—a freedom that, although presocial, may give the artist access to the unadulterated springs of human motivation. These terms also point to the crudity of the concepts on which the primitive view of the world is based and which can keep the artist in touch with the foundations of human experience. Furthermore, reference is made to the primitive form of reasoning in images rather than by intellectual concepts—that concreteness of thought which is at the basis of all artistic representation. Such primordial qualities are preserved more freshly in the cellars of the mind, and they are indispensable. To maintain, however, that these elementary stirrings and notions are the true content of art leads to a primitivistic aesthetics, which fails to do justice to the refinement of the human mind and its products. Art cannot be reduced to the simplicity of the undeveloped mind, because art, a reflection of mature man, is never simple. The apparent simplicity of some truly substantial art is as deceptive as the apparent substance of some truly simple art.

The cult of the "unconscious" in creativity is an aspect of the danger of confusing the elementary with the profound. Cultures in their late stages develop an appetite for primitivism, and to satisfy it they endeavor to see in works of art the crudity of instincts or archetypes dressed up with the trimmings of civilization. But there is no

reason to believe that the areas of the mind farthest from consciousness harbor the deepest wisdom. Wisdom can result only from the concerted effort of all the layers and capacities of the mind, and the prototype of art is not the stone colossus of the Easter Islands but the union of elementarity and subtlety found on the walls of the caves of Lascaux, through the ages, and in the canvases of Cézanne or the figures of Henry Moore. Although Picasso's *Guernica*—like every human product—has primitive roots, the picture is not a manifestation of primitivity.

The present state of the problem is illustrated by Lawrence S. Kubie's book on the "neurotic distortions of the creative process." Kubie objects to the psychoanalytic belief that the source of creative inspiration is the Freudian unconscious. He says that the inaccessible and unacceptable "conflicts, objects, aims, and impulses" produce in the unconscious a "rigid anchorage" and that, on the other end of the psychic spectrum, conscious mental life is made almost equally rigid by "precise and literal relationships to specific conceptual and perceptual units." According to Kubie, the Freudian preconscious, situated between the two petrified extremities, is the creative department of the mind because it is free to gather, assemble, compare, and reshuffle ideas. Eager to overcome the Freudian approach, Kubie describes the motivational forces of the unconscious as entirely negative. In fact, he identifies them with neurotic crippling. Consequently he reduces creativity to a manipulatory device for the "uncovering of new facts and of new relationships among both new and old data"— a mechanism to which he intends to pay a compliment when he compares it with electronic computers. In a chapter entitled "The Neurotogenic Universals" he refers to common human experience as the "banal universals which are the overlooked building blocks of man's creativity and of his neurotic illnesses." It is not clear whether he suggests that banalities should or should not be overlooked, but his own treatment of creativity does indeed underplay these or any other universal experiences, and leaves us with the distressing notion of creativity as the ability for "shaking things up," a mere antidote to routine thinking and mechanization, and a capacity for free association and striking analogy. It is easy to agree with Kubie that freedom from stifling obsession and convention is a prerequisite of creativity; and in the analysis of Picasso's preparations for *Guernica* we shall find many examples of precisely such manipulations. The point is, however, that it would be difficult to make reshuffling operations account for the essentials in the creation of *Guernica* or any other work of art.

Kubie's presentation reflects the inclination among some psychologists to describe productive thinking as a machinelike operation. Speedy mechanical feats are attributed to the brain machine. In a recent paper published in a psychological journal under the title "On Thought: The Extrinsic Theory," there occurs the following terrifying sentence: "Imaginal thinking is neither more nor less than constructing an image or model of the environment, running the model faster than the environment, and predicting that the environment will behave as the model does." Around

the beginning of the twentieth century, American psychologists such as Thorndike described thinking as exactly the kind of mechanism that proved to be the behavior of the modern computers—a turn of events that, curiously enough, has reinforced the belief in the theory rather than discouraged it. The brain machine is said to run mechanically through the entire set of specimens available in a given area in order to pick out the ones that obey certain specifications. It also can find data that fit each other according to some preëstablished criterion.

The mathematician Hadamard's speculations on the psychology of invention in his field show the influence of such theorizing together with the need to overcome it. It is obvious, he says, that invention or discovery, in mathematics or anywhere else, takes place by combining ideas. "Now, there is an extremely great number of such combinations, most of which are devoid of interest. . . . Which ones does our mind— I mean our conscious mind—perceive? Only the fruitful ones. . . . However, to find these, it has been necessary to construct the very numerous possible combinations, among which the useful ones are to be found. It cannot be avoided that this first operation takes place, to a certain extent, at random, so that the role of chance is hardly doubtful in this first step of the mental process. But we see that that intervention of chance occurs inside the unconscious: for most of these combinations— more exactly, all those which are useless—remain unknown to us." Hadamard realizes that nothing in our experience points to the existence of such a mental sorting machine; but since he cannot imagine invention without it, he relegates it to the unconscious. And the emphasis is on "combining ideas."

Gestalt psychologists have described productive thinking as a restructuring of the problem situation. Again the question arises: What determines the direction the restructuring takes? The answer is that the image of the goal situation—that is, a temporary or definitive notion of what needs to be achieved—provides the tension between what is and what should be and, aroused by this tension, the energy necessary for the effort of thinking; it also provides the direction in which the restructuring presses forward. In sum, the various operations of shaping the thought material can be understood only as being controlled by an underlying target concept. Without this concept, creativity presents itself as mere child's play with the building blocks of experience.

Hadamard as well as the Gestalt psychologists refer to the sudden flashes of discovery, so often described by inventors, thinkers, artists. These observations have tended to reinforce the conviction that the truly creative powers are located below the level of consciousness. However, the evidence seems to indicate that these happy solutions do not appear unless intensive conscious wrestling with the problem precedes them. Rather than assume that special creative powers dwell below the threshold of consciousness, we may point to the premature freezing of orientations and connections that may occur in conscious thought and to the greater flexibility, typical—according to Kubie—of what he calls preconscious processes. The constella-

tions of factors, hampered in their mobility by the fixations of the conscious mind, may reacquire some of their freedom when released from conscious supervision, and have a chance to rearrange their mutual relations on the basis of inherent affinities, disparities, and other organizing pushes and pulls. Such a view does not, however, require us to reserve the benefit of the escape from consciousness for the preconscious processes alone, nor does it imply that conscious efforts in creative work are generally harmful or dispensable.

The occurrence of sudden illuminations, which reward the searching mind for its struggle, does not justify an unlimited trust in spontaneity. There is no reason to assume that whatever presents itself "out of the blue" is therefore sent by the gods. Before an artist decides passively to surrender to the spontaneous impulses that come to him from below the threshold, he may wish to remember that such utterances tend to be chaotic. This is known from dreams, which are entangled compounds of many disparate mental processes; it is known from the doodles we draw on note-paper when our attention is blocked or absorbed elsewhere; it is in the word-salad produced by the automatic writings of the surrealists. One is reminded of the cryptic wave patterns written by the recording pen of the physiologist when he explores the electrical activities of the brain by means of electrodes applied to a person's skull. What manifests itself on the surface of the skull is the sum total of many different and not necessarily related processes, which can be differentiated only by expert interpretation. What appears spontaneously at the surface of the mind is equally interesting, equally entangled, equally in need of being teased apart, and illegible to the naked eye. Such spontaneity is valuable as a source of raw material for invention, but different in kind from those sudden happy solutions that are the fruit of much selective observing, sifting, and molding, both conscious and unconscious.

The mere shuffling and reconnecting of items of experience leads, as I suggested earlier, to nothing more than a clever game unless it is steered by an underlying vision of what is to be attained. Such primary visions seem to derive from a way of looking at things which Wordsworth may have had in mind when he wrote that no valuable poems were ever produced "but by a man who, being possessed of more than usual organic sensibility, had also thought long and deeply." The attitude I have in mind here cannot be described simply as "openness to experience." It involves more than passive reception. Wordsworth mentions the two essential components; yet it is not enough to be sensitive and "also" to have thought long and deeply. Rather does the creative person think deeply *through* what he observes so sensitively; and his observation consists in seeing the appearances of our world as embodiments of the significant facts and forces of existence. This perceptual wisdom of the artist could be called the symbolic attitude if the word "symbol" had not been deformed beyond recognition. I prefer to call it the visionary attitude, since artistic vision occurs indeed within the visible world and not outside it. In fact, the nonartistic varieties of creativity are likely to be based on this same visionary attitude, although

9

for many purposes the principles discerned in the appearance of things by the scientist will be of a more limited nature than they are in the arts. Picasso did not simply deposit in *Guernica* what he had thought about the world; rather did he further his understanding of the world through the making of *Guernica*.

The visionary attitude of the creative person consists, then, in what—for the purposes of the painter and the sculptor—can be called "visual thinking." Intellectual abstractions are in no way excluded. Without them the artist would be deprived of one of the most powerful tools of thought. But in order to enter the artistic concept, they are metabolized into visual qualities, so that, for example, the artist's knowledge of the world's being threatened by atomic destruction may reflect itself in his way of conceiving a human figure or a landscape.

Traditionally, "visual thinking" would have been considered a contradiction in terms, since seeing was believed to exclude thinking and thinking to be necessarily removed from concrete perceiving. But it turns out that much of the most creative thinking is done in images and that visual perception involves the sort of operation which was formerly considered the privilege of abstract reasoning.

In visual thinking everything perceived tends to be taken literally. The origin of this attitude has been studied in infants, who, for example, treat an object as though it had vanished out of existence when it disappears from sight. What is hidden is not there. Such is visual thinking in the artist also. What is only partly visible exists only as a part. Locations in space are not accidental: what is placed together belongs together and must be seen in relation. What is close to the eyes is more directly related to the viewer than what is far. When something is placed high, aboveness constitutes a part of its character. A face darkened by shadow or of dark color has darkness as one of its traits.

Naturally, in the course of a person's development the properties of the direct image are supplemented by the memory of earlier experiences, so that a screen is "seen" as hiding an object behind it, a part is "seen" as a piece of a hidden whole, spatial locations are "seen" as being momentary, passing, accidental; and we learn better to distinguish between color that is of the essence and color that is arbitrary or might change. These supplements of direct perception modify what is seen, not only in nature but also in a painting. But since even the most realistic painting must preserve its character as a two-dimensional, timeless object, the image must continue to stress the validity of what is immediately visible in the plane as distinguished from the nature and relations of the objects in three-dimensional space and in the past or future. Needless to say, three-dimensional space and action in time are visual universes in their own right. In them, visual thinking takes shapes, sizes, spatial relations, and displacements equally literally, but leads to different results. This can be seen in sculpture or in the dance.

The second condition of visual thinking is that every perceived property or object be taken to be symbolic. This means that when an object, or part of it, is hidden

from sight, absence is not only one of its optical or physical properties but also an aspect of its state of existence in the broader sense: When only the head of a figure is visible in a picture created by an artist—as distinguished, for example, from a news photograph which may make use of the sense of sight merely for the purpose of informing us of what went on in a certain place—that figure is always to be seen as being incomplete or "merely head" or "devoid of body" symbolically. The ragged shape of a mountain in a work of art always endows that mountain with the character of roughness and sharpness, and, in fact, makes of the mountain an embodiment of its own character—compare, for example, the imminence of disaster embodied in the dark, huge mountain which blocks the path of Dante's Ulysses after he dared to force his boat beyond the columns of Hercules. And when objects are related to each other by location, shape, or color, that relationship is never merely optical or physical, but is always to be understood as an existential tie in the deeper sense. The darkness of *Guernica*, for example, has to be interpreted symbolically. Also, the analysis of Picasso's sketches will show that he experimented with variations of meaning by trying out different relationships among his characters.

Visual thinking treats its material by operations familiar to us from abstract reasoning. It applies some of the logical relationships used also in language. An ingenious description of these mechanisms is available at an unexpected place: in the sixth chapter of Freud's *Interpretation of Dreams*. Freud was not then concerned with artistic activity. He was describing the methods of the "dream work": that is, the transformation of the latent content, or "dream thoughts," into the manifest content actually experienced by the dreamer. For several reasons, not all of Freud's descriptions are directly applicable to the creative process in painting. There are differences of nature and purpose between a dream and a work of art. Also, a dream is an action occurring in time whereas a painting is outside time. Finally, Freud assumed that the devices of the dream work served to conceal the true content of the dream thoughts. On the contrary, we are concerned with the artist's endeavor "to make visible what exists"—that is, we are dealing with means of revelation. Apart from these discrepancies, however, Freud's presentation is remarkably apt. I therefore summarize it briefly, paraphrased to suit our particular purpose.

"The dream is laconic," according to Freud—that is, it condenses a great deal of material in a brief statement. If, for example, a number of persons are pertinent to the dream because of common properties or functions, they may be represented by one person; and if certain themes or objects carry the same meaning or effect, they may appear combined or fused. At the same time, the presentation in the dream is not incomplete, but rather concise and concentrated. There is, then, no one-to-one relationship between the raw material and the representation. One personality or one theme may be split up into its components, which are shown as different entities.

When the whole mass of the dream thoughts "is brought under the pressure of the dream work, and its elements are turned about, broken into fragments and

jammed together—almost like pack ice—the question arises of what happens to the logical connections which have hitherto formed its framework. What representation do dreams provide for 'if,' 'because,' 'just as,' 'although,' 'either-or,' and all the other conjunctions without which we cannot understand sentences or speeches?" At this point Freud refers explicitly to the arts of painting and sculpture, which face a similar problem. By no means can all the logical connections be expressed through visual images, but some can. The dream language is visual and concrete, and it acts out figures of speech. What belongs together is shown together—that is, simultaneity must be understood as a relationship of meaning rather than a mere coincidence in time and space. Freud refers here to the groups of philosophers and artists combined in Raphael's murals *The School of Athens* and *Parnassus*. A tower or a pedestal may be used in the dream to describe the greatness of a man, and so on. In other words, Freud presents the elements of a grammar for visual thinking. Applications of the devices he describes will be found in the preparatory sketches for Picasso's painting.

II THE PAINTING

Let me repeat that no mind but one's own is directly accessible and that, even of his own mind, one knows only the surface layers. How then are we to discover what takes place when a work of art is created? We can listen to what the artist reports about himself—and indeed most of the useful statements on the creative process have been made by the creators themselves. But the value of what they can say is reduced by the narrowness of consciousness, the disturbances caused by self-observation, and the theoretical opinions held by the artists themselves as to what the creative process is assumed to be like. Often the artist tells us what he believes happened or ought to have happened rather than what he was actually able to observe.

To watch an artist at work—to see a film of Picasso or Matisse painting a picture—is revealing; but here again the very private activity of giving birth to a work of art suffers from the presence of witnesses. It is for this reason that the material leftovers of the creative process—the worksheets of poets, the early versions, the manuscripts with their corrections, the notebooks of composers, the preparatory sketches of artists, the various states of etchings, the photographs of work in progress, and the X-ray analyses of paintings—have been seized upon as the most tangible and most reliable data. It is true that by now even those intimate documents of trial and error may be influenced by the artist's awareness that someone may later collect and analyze them. "Paintings are but research and experiment," said Picasso to Alexander Liberman. "I never do a painting as a work of art. All of them are researches. I search constantly and there is a logical sequence in all this research. That is why I number them. It's an experiment in time. I number them and date them. Maybe one day someone will be grateful," he added laughingly. Someone will indeed; but in using the opportunity, that someone must keep in mind that he himself was known to be peeping over the artist's shoulder while the precious circumstantial evidence was produced.

Picasso's remark is relevant to our purpose also because it is one of many indicating that in his view his most significant performance is not any single work or the sum of them all, but the process of fluctuation and continuous transformation presented by the sequence of his endeavors. To be sure, every creative person thinks of the single work as not final but as a mere step to further accomplishment; however, his eye is typically trained upon that final aim to be attained, not on the journey as an end in itself. In Picasso's view, his life's work seems to have a time dimension that is not biographical but an essential aspect of the work itself—not a development either, but rather a stationary flux of transformations. This attitude has influenced the work itself more tangibly at his advanced age. A recent series of some forty paintings, for example, on Velázquez' picture *Las Meninas* represents variations on a theme rather than a set of separate works on the same subject or a string of preparatory sketches. The same is true for the 180 drawings of the "Human Comedy" of 1953; and looking backward, we are tempted to see now the figures of his early "blue period" as a coherent population, as variations on the theme of "man in a state of gloom," and the painter's later oscillatory roamings through a wide range of styles as a unitary aesthetic event depicting the breadth and the instability of modern man's reactions and the absence of progress. If it is true that Picasso creates states rather than objects, his concern with preserving the exact sequence of his works becomes understandable. It follows also that the sketches for a particular work must be considered as having a status similar to that of a sequence of works and that, in addition to representing the stages of a problem gradually solved, they must be seen as variations on the theme of that particular work.

Thus there may be significance in the fact that for the first time in recorded history an artist has created and carefully catalogued and preserved such extensive series of preparations. The material for *Guernica*, reproduced here in its entirety, consists of drawings and paintings plus several photographs taken in Picasso's studio of various states of the canvas itself. A similar dossier exists for the murals *War* and *Peace*, which Picasso painted in 1952, fifteen years later, for the ancient chapel in Vallauris.

After the more or less schematic theoretical descriptions of the creative process found in books, one is almost dazzled by the complexity reflected in the sketches, the range and variety of inventions, the back and forth of the approaches, the side leaps, the abundance of tentative combinations and arrangements.

So eloquent are these drawings and paintings that one is tempted again and again to take them for the creative process itself—for example, to assume, when a drawing shows only a minimum of outlines without detail, that this is all there was on the artist's mind at the time. Actually, he may have thought and imagined much and put on paper no more than a bare scribble—enough to let him look at a few basic features and to remind him of it all later. Similarly, there can be no real continuity in the sketches. Much thinking must have occurred that required no visible record. Nor can we assume that each sketch stands for an equal "quantum of creativity."

At times much invention may have left few traces; at others, several drawings explored one and the same idea.

The illustrations in this book are, in other words, only partial reflections of what went on in the artist. Links and meanings must be supplied by conjecture. Our interpretations should go as little as possible beyond what can be seen. The one fundamental assumption I am going to make is that whatever the painter put down on paper was not arbitrary, accidental, or mere play, but was done for the purpose of furthering his artistic task. Once this is assumed, we must ask at each step: Why did he do this? The answer should always be necessary and appropriate—necessary in that without it we could not account for what we see, and appropriate in that it must not be contradicted by the visible evidence. More than one key will often be found to fit the lock; then we must try to guard against one-sided dogmatic interpretation.

The quest for the correct interpretation is complicated by the fact that every work of art is symbolic by its very nature. The shapes, colors, objects, and events that appear at the surface refer to layers of meaning, which form a scale of increasing abstractness. Thus a particular landscape or still life will reflect a general disposition of the human soul and, beyond that, basic cosmic forces. This depth dimension of the work of art has led to what I described earlier as the error of reductionism: the belief that the true meaning lies always at the deepest level to which the enquirer can dig. Such a procedure leads to the distressing monotony known, for instance, from psychoanalytical interpretations of art—that is, to the assertion that the apparently so manifold variety of artistic statements means in the last analysis nothing more than a few basic things eternally repeated.

What the reductionist overlooks is that every work of art clearly indicates at what level of abstraction it is anchored. It does so by means of what I shall call the "reality level" of the work. The "reality level" is the level of abstraction at which an image represents reality. To illustrate: If we compare, let us say, a still life by Chardin with one by Picasso, we find that in both instances the formal pattern, the spatial arrangement, and the subject matter lead back to basic universal configurations of forces. However, the Chardin is situated closely to the level of material objects, encountered and handled in a physical environment, whereas this same level reverberates as a mere echo in the Picasso. The modern still life neglects material tangibility in favor of prominent perceptual qualities of color and shape, pointing to highly abstract properties of instability, angularity, stark precision, and so on. To be sure, qualities of the latter kind contribute to the meaning of the Chardin also, but as mere overtones. It is not permissible, therefore, to describe the Chardin as primarily a configuration of expressive shapes or to treat the Picasso as an unsuccessful representation of edible food.

Another example may be furnished by a comparison of Picasso's etching *Minotauromachy* with *Guernica*. A description of the events taking place in the etching

proves that the picture is not anchored simply at the reality level of its tangibly material figures and realistic architectural setting. At that level the events make no sense: a huge, dark bull-man shades his eyes against a light held by a young girl; a dead female torera with bare breasts lies on a disemboweled horse. This senselessness at the level at which the scene is represented requires the perceiver to look for a more abstract meaning; it is for this reason that, for example, an interpretation by Herbert Read of *Minotauromachy* in terms of Jungian archetypes becomes possible. Whether or not the bearded man climbing the ladder really represents the "savior or redeemer," the female torera the "overpowered libido," and the child the "bearer of higher consciousness" can neither be proved nor disproved. But it seems evident that the level of interpretation is correctly chosen.

To describe the primary meaning of *Guernica* in these same terms would be a misinterpretation, because the "story" of the mural makes obvious sense at the level of the human implications of a military assault. To ignore the self-sufficiency of the events represented in the picture and to center its meaning instead upon the basic

Minotauromachy (1935) Etching. 19½" x 27⁷⁄₁₆".

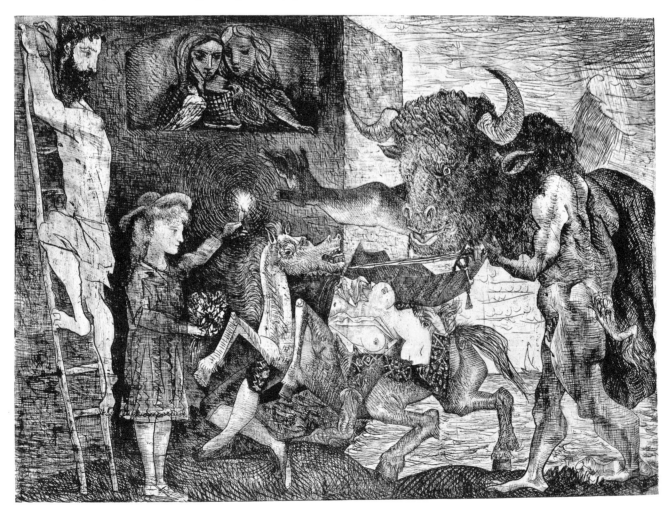

powers of the soul would be as inappropriate as to ignore its highly stylized treatment of shapes and space and to take the picture simply for a document of war reportage. Both reality levels—that of the psychical forces and that of the historical chronicle—do reverberate in the picture and enrich the overtones of its meaning; but they cannot be considered dominant, unless we wish to imply that the stylistic means chosen by the painter are inappropriate for the nature of the work—that is, that he has failed or that he is misleading us and, perhaps, himself.

This reasoning should dispose also of another, related malpractice, to which I referred earlier: that of confusing the interpretation of art with speculations about the psychology of the artist and to describe the work as a portrait of the artist's private wishes and conflicts. Schneider reports that *Minotauromachy* is "portraying varying aspects of the sexual act as it might be conceived by a child"; Goitein finds that in *Guernica* "carnage, castration, and death arise to complete the sado-necrophilic delights of the Unconscious." Although such psychological connotations might conceivably be aroused by the pictures, they cannot be made to monopolize their meanings without causing total disfigurement. Therefore, in choosing the appropriate level of interpretation, we must be guided by the work of art itself.

Another possible misunderstanding of our task should be forestalled at this point. Our enquiry cannot be limited to discovering by indirection what the painter had on his conscious mind and therefore could have told us himself if he cared to and if he remembered. From what I said earlier it will be evident that deliberate conscious reasoning and decision constitute only small fragments of the total process, and that therefore any psychological investigation is bound to describe happenings of which the person himself was not aware. The assertion that the "artist never thought of this" has no bearing on the validity of the interpretation, since the artist, like any other person, does not know what he thought below the level of awareness. We cannot even expect the interpretation necessarily to be plausible to him when he is confronted with it, although a sense of "recognition" may often be his response to the findings.

When we ask: Why did the artist do this? we are not trying to find out the personal reasons that made him select a particular subject and present it in a particular way. Our interest is more limited or perhaps more ambitious; it is concerned with the task rather than the person who accomplished it. Given a particular assignment, why did it induce Picasso to select the subject matter he did? Why did it make him present the subject in this particular way? And what sort of visual thinking led him from the first concept to the finished work? The answers should tell us something about Picasso as an artist. They should tell us even more about the creative process in general.

And now to the painting. In January 1937, the Spanish Government in Exile commissioned Pablo Picasso to paint a mural for its building at the World's Fair in Paris. Picasso was born in 1881 at Malaga, near the southern tip of the Spanish

peninsula. After several preliminary visits he had moved to Paris in 1904, where he had been living ever since. The subject of the Spanish Civil War can be shown to have occupied him before he started to work on *Guernica*, notably in the two groups of etchings *Dream and Lie of Franco*. But the first sketch for *Guernica* was done only on Saturday, May 1, 1937, less than a week after Hitler's military airplanes had attacked and vastly destroyed the Basque town of Guernica.

The commission given Picasso required him to convey in one image the sense of the drama of his fatherland ravished by the Fascists. A war is a long and complex event, likely to furnish the attentive spectator with innumerable facts, strategic, political, statistical, with photographs of warfare, of destroyed cities, of heroism and death, with descriptions by eyewitnesses evoking precise images. Add to this a Spaniard's knowledge of Spain in general—its history, its landscapes, its portrayal in Spanish literature and painting—plus the immense panorama of personal memories, covering the first nineteen years of an alert young man's life and supplemented by later excursions to his homeland. There was, furthermore, the reservoir of images of every kind accumulated in fifty-six years, gathered from everyday observation, from dreams and fantasy, from readings and pictures, from his own prolific oeuvre. Keep in mind, finally, that Picasso works in a century in which society no longer provides rules, conventions, or even suggestions as to the form such a presentation is expected to take. All the styles ever used to picture a public event were at his disposal: the wall decorations in the tombs of the Egyptian kings and in medieval churches, such as those of Romanesque Catalonia; the etchings on the disasters of the Napoleonic war in Spain by his compatriot Goya; the Hellenistic mosaic of the battle of Alexander the Great; or the historical spectacles by Poussin, Velázquez, Rubens, Delacroix. This terrifying wealth and the freedom to use it or to reject it confronted the artist when he attempted to show the drama of Spain to the eyes of the world.

The bombing of Guernica on April 26, 1937, acted as the catalyst for the creative invention. It came as close as any actual event could come to embodying the nature of the total situation Picasso was called upon to depict. The event did not provide him with the image itself, but with the substance of it. Here are, first of all, the facts, as reported by the correspondent of the London *Times*:

> Guernica, the most ancient town of the Basques and the centre of their cultural tradition, was completely destroyed yesterday afternoon by insurgent air raiders. The bombardment of the open town far behind the lines occupied precisely three hours and a quarter, during which a powerful fleet of aeroplanes consisting of three German types, Junkers and Heinkel bombers and Heinkel fighters, did not cease unloading on the town bombs weighing from 1000 lbs. downward and it is calculated more than 3000 two-pounder aluminium incendiary projectiles. The fighters, meanwhile, plunged low from above the centre of the town to machine-gun those of the civilian population who had taken refuge in the fields. The whole of Guernica was soon in flames except the historic Casa de Juntas, with its rich archives of the Basque race, where the ancient

Basque Parliament used to sit. The famous oak of Guernica, the dried old stump of 600 years and the young new shoots of this century, was also untouched. Here the kings of Spain used to take the oath to respect the democratic rights (*fueros*) of Vizcaya and in return received a promise of allegiance as suzerains with the democratic title of *Señor*, not *Rey Vizcaya*.

The "totality" of the event was impressive. This was not just "damage"; it came as close as possible to the total devastation of a complete, peaceful human community. Nor was it merely an attack by the rebellious general; it was the manifestation of Fascist brutality in its universal sense represented by the foreign airplanes and crews. Furthermore, Guernica was not just any small town. There had been earlier air raids on other towns in the Biscay area. In the consciousness of every Spaniard, Guernica represented the very spirit of their ancient pride and freedom. In sum, the murderous incident was pregnant with historical and human meaning. By thus concentrating and externalizing a relevant theme, reality often does preparatory work for the artist.

How does the subject matter of the mural compare with the facts? Obviously, Picasso condensed the event in time and space. No painting can present a sequence of happenings as a film or story can. It is, however, worth noticing that the view is limited to an extremely close environment: the corner of a room plus the lower stories of one or two façades. There is no panorama of the town with the many shells of burned-out, roofless buildings. There is no house of parliament, no church. In other words, this is not a historical chronicle, but a tragedy of human beings envisaged within the close range of the eyes of the peasants terrorized by the disaster. The same approach is apparent in Picasso's use of the figures. In 1937 Guernica had more than 10,000 inhabitants. They could not be crowded into a picture; but what should be noticed is that the mural presents no crowd at all. There are nine figures, each in a different role and clearly distinguished from all the others: four women, one child, a statue of a warrior, a bull, a horse, and a bird. Although all nine are concerned with one and the same event, there is no grouping through duplication of function. Picasso is not a painter of crowds. His *Bacchanal* of 1944, in which a large number of figures are woven into a tissue of common movement and homogeneous function, is done after Poussin. In the larger paintings of subject matters comparable to that of *Guernica*, there are no crowds either, although there are groups. In the *Massacre in Korea* of 1951, there are two tightly packed groups of figures: the women and children as against their executioners. The *War* of 1952 has choruses of fighters, of horses, of "bacteria." In *Peace*, the central plowman is placed between a group of merrymakers and a cluster of four quietly occupied figures, sitting, kneeling, reclining. By comparison, the earlier *Guernica* is individualistic: an image of man, not of the people—of man, split into the various aspects of his reactions.

The plot is acted by women. The one man, half sculpture, half human, is no more than a fragment, an immobile base. Equally immobile is the bull—a monument

19

rather than an actor—whereas the women scream, push, run, and fall. It is true that at the time of the attack Guernica was largely a town of women and children: many of the men were fighting at the front. But there is more to Picasso's choice. The women make *Guernica* the image of innocent, defenseless humanity victimized. Also, women and children have often been presented by Picasso as the very perfection of mankind. In innumerable paintings and drawings he has celebrated their beauty and grace, their vitality and nobility. An assault on women and children is, in Picasso's view, directed against the core of mankind.

Guernica was attacked on a sunny spring afternoon at 4:30. Soon the streets were dark with the smoke of fires; but the bombing did not occur at night, whereas the painting clearly suggests darkness. The black setting, then, which is broken by the figures, flames, and lamps as though by erratic flashes of light, must have been chosen because of its immediate symbolism. Thus, the event is interpreted as being visible—existent—only because of the lamps and the flames. The fire is the companion of brutal destruction, but its flickering reflections are also enlightening because the Fascist attack dramatized the rape of the Spanish people. There are two lamps—a duplication that seems bothersome at first. One of these is pushed violently and forcefully into the center of the scene. It is a modest oil lamp, thrust forward by the woman who leans out of the window; but it is also the apex of the compositional triangle which comprises the warrior, the horse, and the running woman, and which is at the same time a pyramid of light. Placed at so dominant a spot, the small lamp, held by a townswoman—whose head is, however, transfigured into the shape of a dazzlingly white comet—is not merely a means of uncovering the events of the night. It is also a beacon on the top of an almost invisible but nevertheless powerful central column—a potential support—which is all but hidden by the chaos of destruction. Compared with the strength of the oil lamp, the large luminary at the ceiling is almost inert. It is not propelled by anybody, and its effect as a giver of light is not apparent since it is outside the cone of illumination. It is lamp, sun, and eye, but these meanings interfere with rather than support each other. This sun is nothing but a lamp, the pupil of this eye is nothing but a bulb; there is the coldness of an inefficient power, whose somewhat disheveled rays, isolated in the dark and casting shadows as though they were paper cut-outs, do not seem to warm or brighten anything. Here, then, is a symbol of detached "awareness," of a world informed but not engaged. The apparent duplication of the light source actually expresses a significant contrast between the true, small light, whose participation brightens the scene, and the powerful, but blind instrument of a consciousness without conscience.

One further deviation from the historical facts should be mentioned here. The enemy is not present. On the fateful Monday afternoon, says an eyewitness, "five minutes did not elapse without the sky being black with German airplanes." There is no sky in the painting, and there are no airplanes. The composition is not based on the contrast of two antagonistic parties, as in Picasso's later political works: the robots with their automatic rifles facing the Korean women, or the germ-spreading

devil on his chariot advancing toward the fighter with the dove of peace on his shield. There is no such dualistic antagonism in *Guernica*, which keeps the mural from being a political statement. It depicts the effects of a brutality that strikes from nowhere; it speaks of suffering and of hope.

I am treating Picasso's objects as symbols—by necessity, because they are expressive shapes in a work of art. All expression communicates the possession of certain properties, and all properties are generic, not particular. It is upon these generic properties that we focus when we treat an object as a work of art. In this sense, then, *Guernica* is like the art of any other period. There is, however, an important difference in the degree to which the pictorial style of a work is made to serve the representation of the subject matter. A glance at Goya's *Desastres de la Guerra* illustrates the point. There, another Spaniard, more than a century before *Guernica*, described the horrors of another foreign assault. Again the descriptions have survived the occasion because they express universal human experience. But most of Goya's etchings are clearly episodic. In each of them we seem to watch an actual event as it could have happened. There is, for example, a scene in which a desperate half dozen men and women face a firing squad. If in this picture we were to see the fragments of the statue of a warrior, we would either take it literally for what it purports to be or we would call it a "symbol." By "symbol" we would mean that there was no actual piece of broken sculpture in the locale of the picture but that it was introduced for its meaning only. In order to distinguish such a device from symbolism in its more general sense, I may be permitted to use the term "allegory." Goya dispenses with allegories for approximately the first seventy of his etchings, but the last dozen of his series are clearly different. The man with the claws and the bat wings, the animals with human shape and function, the rope-dancing priest, the luminous maiden of Liberty or Truth—these are not meant to exist in either the real or an imagined world. They exist, like the characters of *Minotauromachy*, only as conveyors of meaning.

Whether or not an object or event is to be seen as an allegory depends on what I earlier called the "reality level" of the picture. Any painting, of whatever style, represents reality, but it does so at different distances from realistic appearance. The reality level is determined by the subject matter, but also by the rendition of shape, space, and color. The deformed figures of much modern art are not monsters when they appear in an equally deformed world. Few of Picasso's deformed women and children are properly interpreted as "distorted." The creatures of Bosch or Brueghel are monsters because the realistic treatment of shape, color, and space puts them in a setting of material solidity, in which their shapes and actions must be taken literally. They are not allegories in my sense of the word, however, because they are shown in a world that establishes such monsters as real—a phantastic world. Not so in Goya, who, in the final etchings of the *Desastres*, tells no fairy tales. He introduces creatures that make no self-sufficient sense in the world in which they are presented. Therefore they must be taken as allegories.

21

The excursus was necessary in order to show that in *Guernica* there are no allegories. Neither the broken warrior nor the bull nor the bird is a stranger in the setting of the picture, in the sense in which—to use one more comparison—the female figure of Liberty, waving the flag in Delacroix' *Liberty Leading the People on the Barricades*, is a stranger among the faithfully portrayed contemporaries of the painter. By 1937 the art of painting had made possible a reality level at which deformities of shape and space and incongruities of subject matter portray the world as it *is*. At that level the broken warrior and the frightened women have equal reality status. But in order to establish this level, the painter had not only to remove the appearance of the women and of the setting sufficiently from that of the actual Basque town and its inhabitants, he had also to dematerialize each object and to break up the continuity of physical space. The fragmentary statue could not assume the same status as the horse if the volume of the horse's body were not similarly decomposed into fragments in the cubist manner. In other words, the search for the proper style, which, as the sketches will show, was a principal concern of Picasso's, cannot be considered a matter of whim or taste. Since the reality level required by the meaning of the picture strictly determined the amount and kind of deviation from realism he could introduce, he had to find for his shapes the style that corresponded to the appropriate ratio between the faithful portrayal of a historic episode and the expression of certain ideas. His way of drawing an eye or hand anywhere in the picture determined whether the bull would appear as a domestic animal in a Spanish town, as an apparition, a miracle, an allegory, or as one of a number of figures intended to depict suffering and hope through a war episode.

The figures populating *Guernica* are not mere reflections of the images aroused in the painter by the newspaper reports on the bombing of the town. In fact, much of the "cast" can be found, as has been frequently observed, in the *Minotauromachy* of 1935. What is more, if we invert left and right—an alternation always to be considered in an etching, which is inverted in the process of printing—we find an almost identical arrangement in both compositions. First the bull, then the disemboweled horse in agony, combined with a dead fighter brandishing a sword; then a female figure uplifting a light, and the motif of women looking out from a high window. Bird and flower are also present, and the sketches show that a figure climbing down a ladder was considered by Picasso temporarily for the right wing of the *Guernica* composition. I cannot here undertake a comparison of the two works. But such a comparison would show to what an astonishing extent an artist's images are independent of the meaning he makes them carry in any particular instance, and would help to keep us from assuming automatically that the same pictorial motif represents the same meaning in different contexts.

This holds true particularly for the bull. This impressive animal has a long and noble history in the culture of the Mediterranean peoples, a history reviewed—somewhat fitfully—in a book by Vicente Marrero. It suffices to recall the images of Mithras subduing the sacred bull, who was created by the god of light and from

whose corpse sprang the life of the earth; or the friezes and statuettes of Cnossos, the home of the dreaded Minotaur; or the spectacular fights in the Roman amphitheaters. In an agricultural country the bull appears as the admirable and redoubtable king of the beasts, an image of power and fertility, but also of fierceness. In the bullfights, he is the dark fiend, the adversary of the human hero who wears the *traje de luces*— the suit of light; at the same time, he is respected as worthy of his partner, and Marrero speaks of a kind of "mysterious and sympathetic similarity—between the fighter and his enemy," suggested by the two points of the torero's hat, which resemble the two-pronged horns of the animal. Many-faceted is the image of this Spanish symbol, and its elusive character is faithfully reflected in the life work of Picasso.

What is the meaning of the bull in *Guernica*? The painter himself has given us but a few, vague hints. If we inquire among his countrymen who have written on the subject, we remain baffled. Marrero says:

Picasso, child of the century, in painting terrible, repellent bulls expresses a truth regarding the period of history in which we all must live. [In *Guernica*] a threatening bull with curled tail dominates the entire composition; its snout seems to rest on the head of a desperate mother . . . [and] when all is said and done [Picasso's concept of the animal is that of] the mythical figure of the bull which rapes Europe. [On the contrary] there is never anything repellent or horrible [in his horses.] There is something indomitable about them, but there is also something innocent, a kind of purity, the calmness of the horse which has nobly ridden between the perils of life and the spur. White is the preferred color for these horses.

Juan Larrea, in turn, says:

On the table a dove is seized by a spasm, like all the other figures, with the sole exception of the bull which, bellowing and nearly bursting with fury, its eyes fixed in their orbits, seems about to charge at the moment least expected. . . . the bull seems to be the symbol of the people, and the more so because this animal is almost the totem of the Peninsula, and Spaniards attend its sacrifice with passionate enthusiasm. In the larger part of the notations and sketches which Picasso devoted to it, it appears with a handsome human face, impassive or even glorified. It reappears in the same style and manner in the etchings known as *Sueño y Mentira de Franco* . . .

Picasso's horse, on the other hand, is "invariably full of ignoble and depressive features," and there can be little doubt that it "stands, in the painter's mind, for nothing more nor less than Nationalist Spain."

We turn to looking at the picture with our own eyes. Surely, the bull is a dominant figure. He is not so overpoweringly huge as the bull-man of *Minotauromachy*; but, as in the etching, all eyes are upon him. The outcry of the mother is directed toward him, and so is the face of the dead child. The warrior gazes at him, and with his outstretched arm he supports him as a kind of pedestal. The screaming horse looks

at him, one of the women pushes the lamp toward him, and the fugitive woman runs and stares in the same general direction. Only the falling woman to the right is, in her aloofness, the symmetrical counterpart of the equally detached bull himself. But whereas the falling woman, in mid-air, presents the extreme lack of support, the bull is the other extreme of stability—the only one to stand solidly on his vertical legs. The falling woman's isolation is that of final catastrophe. The bull is outside that catastrophe, appealed to, but unaffected. He protects the distressed mother like a roof, but fails to react—not because he lacks feeling (his internal passion is expressed in the flaming tail) but because he is obviously absent from, though relevant to, the scene. His head, together with that of the light-bearing woman, is the only large, compact, unbroken shape; and his perfectly fashioned, steady eyes are what remains of that classical, serene image of the bull appearing in the sketches and then discarded because it would have carried the contrast to the point of breaking the stylistic unity of the whole composition. Absent from the episode of disaster but relevant to it and therefore "in the picture" is the imperturbable image of Spain, towering like the tree of Guernica and the Casa de Juntas, which remained untouched by bombs and fire. Framed by a niche of stable architecture, the spirit of Spain does not appear here as the active fighter of the *Franco* etchings, in which there are three episodes of the bull overpowering the repulsive caricature of the dictator. *Guernica* is not victory but defeat—a sprawling chaos, shown as temporary by its dynamic appeal to the dominant, timeless figure of the kingly beast.

Apart from the internal evidence, which I have tried to present, the alternative interpretation of the bull would have consequences for the ideological meaning of the mural which would hardly fit its purpose as a "keynote" for the Spanish building at the World's Fair and which, in addition, would have been disturbing to anybody at all sympathetic to Marxist thought. If the bull represented the enemy, the mural would be an image of callousness, destruction, and distress only—a lament, rather than a call of hope, resistance, and survival. It would be the sort of art condemned by Communist theorizers as sentimental, rather than revolutionary—as indulgence in the heart-rending suffering of the victims, rather than a vigorous appraisal of future salvation. A painter who was to associate himself so closely with the Communist party could hardly be unaware of the sort of aesthetic doctrine expressed, for instance, in Bertolt Brecht's comparison of the dramatic versus the "non-Aristotelian" epic theater. According to Brecht, the traditional dramatic theater entangles the spectator in a stage action; it consumes his activism, allows him to lose himself in feelings and to empathize with the events as though he were in the midst of them. The revolutionary epic theater, on the contrary, makes the spectator an observer and awakens his activism; it forces him to come to decisions by detaching him from the events and thus making him face and judge them. Picasso may never have read Brecht; but his pictorial reference to the indomitable spirit of Spain fulfills at least three of Brecht's demands: it detaches the spectator from the immediacy of the horror

story, it makes him ponder the situation, and it instills him with the invigorating thought of future rehabilitation—not to mention the aesthetically most relevant broadening of the philosophical and religious concept, from suffering as the state of man to suffering as a contingent affliction of the indestructible human soul.

After discussing some aspects of the subject matter, we need to look at the more formal characteristics of *Guernica*. First of all, the painting is approximately monochrome: built on the scale from white to black alone. This is not a necessary consequence of Picasso's decision to make the picture a night scene. Two years later he painted *Night Fishing at Antibes* in full color. Whether or not Picasso planned *Guernica* as a monochrome from the beginning cannot be ascertained. There is some coloring in some of the sketches, but there exists no version of the composition in color. The decision had important consequences. In relation to the colorful world of everyday experience and the equally colorful look of much painting, monochrome gives a picture the character of a reduction. This is a particular form of removal from reality in that the work does not so much present "another world" (as a painting in strong unrealistic hues might) but rather "less than the world." By comparison to a work in many colors, a monochrome is always strongly abstract, less substantial materially, closer to a diagram—the visual representation of an idea. In *Guernica* there is no red blood, no difference between fire and light or between the complexions of the dead and those of the living. The image is reduced to expressive shapes, which are interpretive rather than narrative. The flames have the generic sharpness of saw teeth, but they do not burn. Monochrome, in other words, tends to move the image in the direction of a disembodied statement of properties rather than a rendition of objects. It emphasizes the detachment of the "epic" presentation.

At the same time, monochrome creates a uniformity which reduces all events to the dramatic contrast of light and darkness. In the world of color, the distinction of light and darkness is one distinction among several and therefore does not have the weight of exclusiveness. In the monochrome world, the fate of darkness is unmodified and the brightness of light is absolute. All objects are classified and judged by one color scale only—as to where they stand with regard to white and black—which calls into play the powerful spontaneous and traditional connotations of good and evil, God and devil, victory and defeat. In *Night Fishing*, no such clear-cut relation connects the yellow and bright lamp with the blue and dark bodies of the fishermen. Other color associations cross and contradict this one, thereby tempering its apodictic strictness.

Because in *Guernica* everything is reduced to one dimension of color, the painting does not offer the sort of grouping and separation frequently contributed by color composition. In *Night Fishing*, the lights are a segregated class of objects because of their yellowness. In the *Massacre in Korea*, the two groups of the women and their executioners are both held in shades of neutral gray, which connects them with each other but detaches the entire foreground of figures from the more realistic greens and

25

browns of the landscape. In *Guernica*, the fundamental distinction between the bombing scene and the bull is not strengthened by different coloring. Instead, the uniform black and white stresses the unity of everything contained in the picture. Whether dead or alive, human or animal, assaulted or unassailable, all the figures belong to the same clan, to Spain, to afflicted but immortal life. At this level the sufferers and the bull are complementary aspects of one and the same subject.

This uniformity of color is related to the format of the painting, the long-stretched rectangle of 138 by 308 inches: a ratio of 1 to 2.2. The picture is more than twice as long as it is high. To some extent this ratio must have been determined by the shape of the wall in the Spanish Pavilion for which it was done. But, according to the architect of the Pavilion, José Luis Sert, the mural did not strictly fit the wall, which was even longer. The ratio is essentially of Picasso's own choice and is in fact identical with that of the *War* and *Peace* murals, done later for a different building. (*Korea* is relatively small and a bit shorter, with a ratio of 1 to 1.9). By selecting this format, Picasso waived the opportunity for a strong climax, to the extent to which a climax is expressed by height. The bull does dominate the scene, but he is only slightly higher than the other figures. More essentially, he is an integral part of the total composition, in which every element commands equal stress. Like the monochrome, the long format has an equalizing effect; it makes the picture tell an epic rather than a dramatic story.

The long panel makes, furthermore, for a lack of compactness—that is, in the vertical the elements are closely related, but they can be far apart in the horizontal. The uniformity of color, shape, height, and spatial depth is counteracted by a panorama-like sprawling in the horizontal. Instead of tight cross-connections, there is a loose enumeration of separate happenings. The spectator's eyes, traveling along the canvas, inspect a sequence of themes rather than encounter a highly integrated structure, which would make the total content of the frame appear as one coherent although subdivided object. The world envisaged in *Guernica* is one in which much the same happens everywhere but without strong over-all organization.

Picasso prevented the composition from falling to pieces by the symmetrical correspondence of the flanks—the bull at the left, the falling woman at the right—and the roughly equilateral triangle culminating in the oil lamp. The triangle is low, vaguely outlined, pierced by protruding shapes, and there is no tidy distinction between what is going on inside it and outside it. Many shapes, similar in size and character, strongly bent, jagged, narrow, cover the total surface of the canvas rather evenly. There are three areas of let-up, breathing spaces, on the left, on the right, and in the center. The foci of intricacy, the tight scramble of intertwined shapes, are all in the lower half of the picture and more intense on the left. This adds to the density of the chaos and weighs the scene down while leaving at the same time some freedom to the upper region of the lights, the flames, and the more significant heads.

If it is true that *Guernica* owes some of its visual unity to the uniformity of the shapes covering the surface rather evenly, there is still a far cry from Picasso's work

to the recent vogue of texture painting, which makes the spectator find himself in the same place regardless of where in the picture his glance settles. There is no such monotony in Picasso's composition. Certainly, *Guernica* has enough of the style of twentieth-century art to prevent us from interpreting its structure by means of those sweeping trajectories which are used by teachers of art appreciation to guide their students through a Poussin or Rubens. But the presence of the triangular pediment, which fills half of the painting's surface, is sufficient to prove that even in this work certain over-all groupings and directions organize the assembly of shapes.

The apex of the pediment at the top of the oil lamp is not located in the exact center of the painting but slightly to the left of it, and the position of the large ceiling light helps to move the culmination of the central mass even further to the left. This displacement accentuates the lateral movement of the wave of figures—the horse, the woman with the light, the fugitive woman—directed toward the bull. Any compositional movement toward the left, however, runs against the tide, because for psychological reasons the observer's glance proceeds freely from left to right whereas it is impeded in the opposite direction. The basic symmetry of the pictorial rectangle is, in fact, overlaid with a rightward current, which introduces an element of asymmetry and sequence. Thus viewed, the painting starts with the bull as the gatekeeper or, more exactly, with the small, relatively independent and self-sufficient family group of the bull protecting the grieving mother and her dead child —a motif that anticipates the theme of the whole in a nutshell. Outside this introductory island, the glance starts its path in the lower left corner with the hand of the statue, which marks the beginning like a star in a diagram, and from there stumbles upward over the debris of organic shapes, runs into the open mouth of the horse, and reaches the ambiguously marked apex laboriously and uncertain of the goal, only to glide downward much more smoothly until the foot of the running woman designates the end. Surely we must not read the picture in terms of this sequence alone, because such a one-sided orientation would mislead us into starting with the reassuring theme of the bull and ending with the hopeless fall of the burning woman. This would lead to an inappropriate interpretation of the artist's statement, because in doing so we would overlook the basic architectural symmetry of the work, in which, as I said earlier, the bull and the falling woman are corresponding opposites, not beginning and end. However, we must recognize that within the central pyramid the rush of the figures toward the bull is severely checked by being oriented "against the grain." The meaning of this factor becomes evident when the painting is viewed in a mirror. As soon as left and right are inverted, the scene changes to an unchecked stampede toward the bull. Compared with the actual painting, this would be an intolerable simplification. In Picasso's subtle concept, the bull's body faces the victims but his head is turned away from them, and his glance transcends the space of the scene entirely, focused as it is upon the infinite. The victims, although oriented toward him, are kept away from him by the pressure of an invisible containing force, and it is the tension of these antagonistic powers that makes the enclosure within

the triangular area dynamic rather than statically confining. The beacon of salvation, discernible but not reachable, provides the target for the enclosed victims, who convey the impression of being trapped only because their attention is shown to be centered upon an objective beyond their range.

I shall complete this analysis and at the same time provide a transition to the examination of the sketches by pointing out that three sets of factors can be distinguished in *Guernica*: a set of characters, a set of expressive attitudes, and a set of sentiments. The combinations of these factors will occupy us in the following.

As far as the characters are concerned, we find human figures and animals endowed with at least equal importance and entrusted with similar roles. Why animals? One can point, pedantically, to the agricultural setting, although as a matter of fact the reports on the bombing of Guernica mention neither horses nor cattle but describe flocks of sheep machine-gunned by the German planes. In any event, it is surely not a concern with faithful documentation that placed Picasso's animals in the picture. Presumably he introduced them because, first of all, we attribute to animals simple, elementary, but strong reactions. Second, when animals are given the status of human actors, as they are here, they tend to stand for one particular mental attitude, as they do, for example, in fables. Whereas in the image of a human figure the properties attributed to it are subservient to it and belong to it by contingency rather than by necessity ("a man who happens to be strong"), the animal appears as subservient to the property which it represents and which it possesses by the necessity of its very nature ("strength, embodied by the bull"). Therefore the animals in *Guernica* depersonalize, purify, and intensify the human properties for which they stand.

The bull has been discussed. I will add here that we need only look through Picasso's life work to realize that the powerful animal is identified with Picasso himself, with the creative artist, the lusty, overpowering male. The curly, heavy-headed artist of the etchings *The Sculptor's Studio* is distinctly bull-like and in fact appears in close conjunction with the animal. The Minotaur, in subduing his women, has lost much of his Cretan savagery, and rather embraces his victims with the naïve *joie de vivre* of a frolicking Zeus. Picasso's fascination with the mythical figure of the bull-man suggests that the animal is an impersonation. This does not reduce the bull of *Guernica* to a "personal symbol," but limits the range of the meanings the animal is likely to assume in Picasso's work.

The horse, the passive victim of the bull fights, suitably embodies laceration and pain. Its torn body holds the center of the composition, and to its head is assigned the most vocal expression of suffering. The bird, related presumably to the dove of peace and—as we shall gather from the sketches—an image of the surviving soul, looks like another embodiment of lament stricken with darkness.

The male element, confined to the left side—which in *Guernica* and frequently elsewhere in Picasso's work harbors the most stable aspect of the composition—is made to present two extremes: the untouchable tower of strength in the bull, and

the equally unimpressionable fragments of the fighter, who is broken rather than wounded, a statue rather than a man of flesh and blood, defeated in the purely military and historical sense, a mere base for the display of human sentiments. Within this male framework of the vertical axis of the bull and the horizontal of the shattered warrior unfolds the spectacle of *Guernica*, centered in the sexually neutral horse—suffering knows no distinction of sex—and entrusted for the rest to the women. The feminine element is divided into four functions: the lament of the mother, the light-bearing witness, the fugitive, and the falling victim; and we shall find that this final distribution of functions was the result of considerable experimentation.

The various figures are characterized by different expressive attitudes, which are, in essence, differently oriented directions in space.

CHARACTERS	ATTITUDES	SENTIMENTS
bull	upright, leftward, forward	courage, pride, stability
mother	upright, upward	lament, imploration
child	downward	death
warrior	horizontal, upward	collapse
bird	upward	lament? ascent?
horse	upward, leftward	agony
light bearer	leftward	concern, quest
fugitive	diagonal, left-upward	anxiety, quest
falling woman	upward, downward, diagonal	panic, imploration

We look to the sketches for the answers to some of the following questions: Was the cast of characters established from the beginning? To what extent did their locations and mutual relationships change? Were definite attitudes associated with definite characters immediately, or were these relationships variable—if so, within what range? Were there changes in the sentiments attributed to the characters? Did sentiments change carrier? How stable were the relationships between sentiments and attitudes during the creative process?

III STEPS TOWARD GUERNICA

"It would be very interesting," said Picasso, two years before he painted *Guernica*, "to preserve photographically, not the stages, but the metamorphoses of a picture. Possibly one might then discover the path followed by the brain in materializing a dream. But there is one very odd thing—to notice that basically a picture doesn't change, that the first 'vision' remains almost intact, in spite of appearances." A moment later he is reported to have said: "A picture is not thought out and settled beforehand. While it is being done it changes as one's thoughts change."

THE SKETCHES FOR THE MURAL

1

Probably both the above statements are pertinent. Picasso's first sketch for *Guernica* contains much of the final basic form; the small drawing on a piece of blue paper certainly comes closer to the composition of the mural than anything else the painter put down before he started on the actual canvas. We discern the bull on the left, in his final location. Not only the head but the entire body is turned away from the scene—as though this turning away was the basic thought, later refined when the bull was made to face the event but with his head averted. The bird sits on the bull, at the exact spot where it will later hover on the table. The horse seems to lie dead on its back, thereby representing the extreme effect of the murderous assault—a function later transferred to the dead child. The horse's raised hindlegs are significant as the early establishment of a central rising vertical, which later caused much experimentation. The woman is pushing the lamp through the window; she, too, is in her final place. The horizontal base of prostrate bodies underlies the entire principal scene, more radically and simply than the warrior will finally do it. A vertical

1 *Composition study* Pencil on blue paper. 10⅝″ x 8¼″. Dated
 "May 1, 37 (I)."

element is clearly indicated at the extreme right—is it a part of the building, or a figure, or are there two figures?

We cannot tell how much Picasso's image went beyond what he hastily penciled on this piece of paper. From what we see we can infer that there were four basic elements to the concept and that they stood starkly for four basic positions: the upright bull, the light bearer, the sprawling victim, the inert base of destroyed bodies. The first and fundamental role assigned to the feminine element was that of making light; the lamenting women began to appear a week later. The rival luminary is not yet at the ceiling.

The sheet of paper is of the ratio 1 to 1.2, and the composition itself is approximately of the same format. Is this more squarish shape accidental, determined simply by the shape of the first piece of drawing paper which came to hand? Or did Picasso in the beginning think of a more compact pattern? The light is already placed in the center, but it tops no triangle as yet. Instead, there is a large circular curve, for which the final composition would have no room and which is obviously designed to pull the vertical and horizontal dimensions together in order to produce a more tightly unified whole. The cast of characters is still small, and demands little floor space. The arrangement of the scene is closer to the classical pictorial tradition than the final mural will be. It is less "modern."

31

2

Later on the same day and on the same kind and size of paper Picasso sketched this second scene—or does the drawing represent two scenes? At the top, one vaguely discerns the bull turned to the light-bearing woman. At the bottom, he is combined with the horse. Did the painter, for the purpose of undisturbed analysis, separate the two basic relationships, which were combined in the first draft? In any event, by halving the surface he gives to each of the two scenes a format of about 1 to 2.4, which is close to the final shape of the mural.

Some left-over lines in the bottom scene suggest that horse and bull were at first less intimately connected. The human mind tends at first to distinguish the various elements of a situation neatly from each other and only later attempts to make them interact. Even now the heads and necks of the two animals do not overlap, but their bodies do. It is an overlap that intertwines them but does not yet commit the painter to making one of them dominant. The bull was drawn first, the horse later, but neither of the two is in front or in the back. Also, their orientation in space is similar —as though, at least pictorially, the two animals had still the same function. The horse is no longer dead. It has begun to play an active role: for the first time we see the combination of collapse and upward-directed appeal, which will remain a basic theme.

The small winged horse is not casually perched on the bull's back; it has mounted him and rides solemnly. In fact, the bull seems to be saddled and bridled. At the same time the general shape and attitude of rider and mount are so similar that they must be considered close to each other in spirit—a parallelism perhaps hinted at in the final composition also. We learn something about the nature of the bull from his affinity with the winged horse, which is well defined by its classical connotations. It was Pegasus, the winged horse of the poets, that sprang from the blood of the dreadful Gorgon Medusa, slain by Perseus; and it was Pegasus that helped heroic Bellerophon to defeat another monster, the Chimæra, which had a lion's head, a goat's body, and a serpent's tail.

Although the small winged creature is close to the bull by contact and attitude, it is akin to the horse by species. Here the connotation is no less ancient: it is that of Psyche, the maiden with the butterfly wings. It is indeed the soul of the horse that sits on the back of the bull—a further confirmation of the close connection between bull and horse. The horse is condemned to suffering and collapse, but it is also—by virtue of the bull's support—immortal and untouchable.

The winged horse is what Freud would call "overdetermined," untidily endowed with all sorts of associations. As the creative mind sifts and shapes the teeming raw material, the creature will finally turn into a bird, thereby limiting its range of meaning.

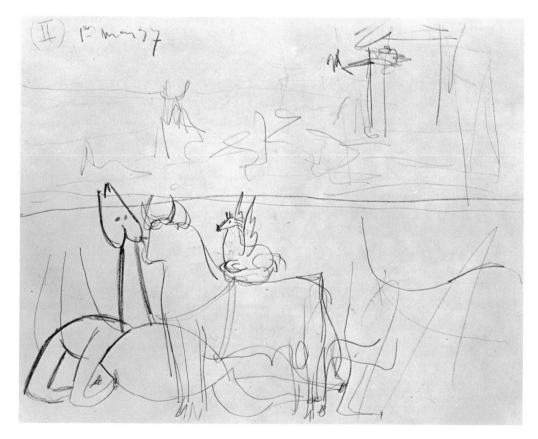

2 Composition study Pencil on blue paper. 10⅝″ x 8¼″. Dated
 "May 1, 37 (II)."

33

3

Among the sketches of the total composition, is this the only one not to contain the bull? Probably so. In fact, rather than rendering a concept of the whole work, this drawing seems to present an inventory of the attitudes to be confronted by the light-bearing woman—attitudes conveyed by one and the same vehicle: the horse. The painter repeats the collapsed horse with the erect neck and head—a "phallic horse," for the purposes of the psychoanalyst. Below, the neck is bent in agony. Until the last minute Picasso will vacillate between the two attitudes of the horse: the more active and the more passive.

There is little over-all unity. The two animals at the right are fenced off by a circle and a rectangle respectively. The circle emphasizes the disemboweled body, earmarking it, as it were, for the role of the central mass which it is going to assume in the final mural. The meaning of the curiously boxed-up creature at the right is perhaps explained by the word "bas" written next to its head and indicating apparently where it should go and how it should be oriented in space. "Below"—a horizontally extended figure—is this horse standing in for the prostrate statue of the warrior, for his function as the base of the composition?

All that needed to be recorded in this drawing, the painter was able to express with a childlike simplicity. That is why he did not draw "better". Simplicity is not only economical; it also helps to clarify the essentials of the statement. At different stages of the process, the creative thinker must dwell at different levels of abstractness in order to deal at one time with the bare structural elements and at another to seek the proper shape for the refinements of appearance.

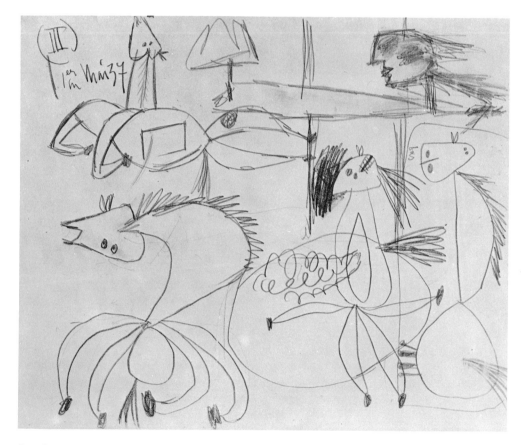

3 *Composition study* Pencil on blue paper. 10⅝″ x 8¼″. Dated
 "May 1, 37 (III)."

4

It looks as though, after twisting the horse into the attitudes of the various basic sentiments, the artist had to help himself remember what a horse is in itself. All distortions must be readable to the perceiver as deviations from the norm, and it is the norm that Picasso recalls in this simple drawing—the way a composer of music will establish and keep in evidence the tonic of the key in which he is writing. Picasso sometimes invents "atonal" figures in which the norm, from which they derive, is no longer perceivable but can be associated with them only on the basis of what the observer knows. Not so here.

The horse is to remain a horse. The basic directions and proportions are recorded. But as in a young child's drawing, there is no need to present the head entirely from one point of sight. A different criterion of unity applies: all features, although clearly related to each other, must retain their visual integrity. Of the three pairs of facial organs, two are given in profile, one frontally. The belly is a self-contained and closed unit, geometrically simple. So are the other limbs or parts. An elementary order is achieved.

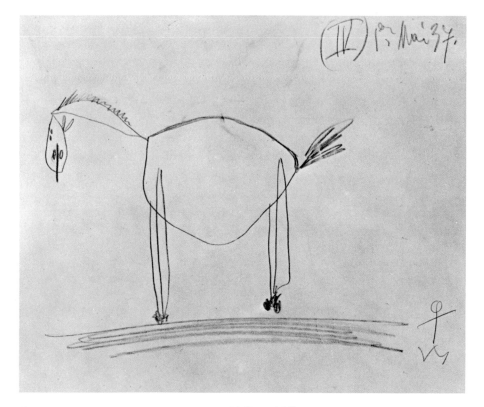

4 *Horse* Pencil on blue paper. 10½″ x 8¼″. Dated "May 1, 37 (IV)."

5

Once the structural skeleton is firmly established, the shapes can be complicated and their relationships changed to suit the demands of anatomy, expression, style. Instead of a configuration of self-contained geometrical shapes, one now sees functional units gliding fluently into each other. The legs are bent at the joints, and no longer correspond to each other symmetrically. The painter has shifted the reality level to a less abstract one in order to approach more closely the sense of the living animal and to express a complex state of affairs.

The pentimenti seem to indicate that Picasso started with the position familiar from sketches 2 and 3: reposing on its belly with forelegs bent and hindlegs stretched backward, the horse raised neck and head stiffly. By the time the drawing is done, however, the legs illustrate four different stages between standing and reclining. One of the right legs, which is further removed from the perceiver, is close to being distended upon the ground; the other rests on the shin, but helps firmly to support the raised frontal part of the body with its thigh. One of the dominant left legs is bent but standing, the other almost upright. These stages of collapsing or rising—most pictorial representations of movement can and must be read in two opposite ways—reflect a much more subtle invention and also introduce strong dynamics. The torso slants diagonally, and a correction of the first pencil lines deflects neck and head from their original straightness. The open mouth screams. If Picasso had intended nothing more than to show a horse in agony, this drawing would have been close to the solution. But the horse was to be a part of a group, whose task it was to make a human tragedy visible.

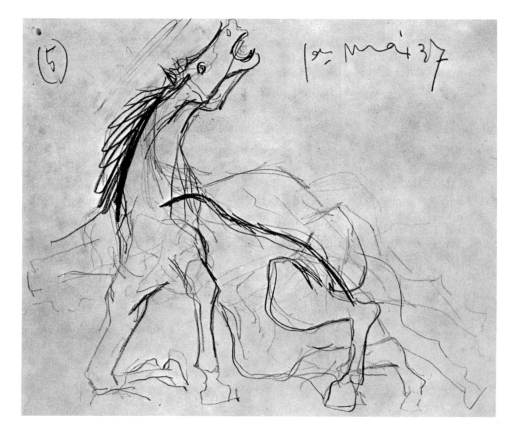

5 *Horse* Pencil on blue paper. 10½″ x 8¼″. Dated "May 1, 37 (5)."

6

The output of the first day is rounded off by a large sketch of the total composition, which presents the protagonists familiar from the first attempt but in a significantly different arrangement. In the beginning every element was separately defined and located, but now they are all awkwardly interwoven. Much organizing remains to be done.

Since the picture is nearly a square (1 to 1.2), there is hardly any unfolding along the horizontal dimension. The eye has to unravel a tight cluster. The schematic image of the bull in almost unrelieved norm position dominates the scene by its size and by monopolizing an otherwise empty quarter of the space. His forehead is decorated with flowers. He is turned away from the scene—a position which bestows upon his hindquarters and testicles the hardly deserved honor of sharing the central area with the lamenting horse's head. The composition is particularly unrewarding when we enter it, as usual, from the lower left corner: stumbling over three pairs of legs and a stick, we run straight into the horse's anus beneath the marquee of the tail. There is a similar jumble of limbs in the lower central area. Inferior anatomy clutters the view of the observer, who looks for significance.

The horse maintains the diagonal position worked out in sketch 5, but the pattern is greatly simplified: body and head point in the same direction, and the functions of the legs are reduced to two: the bending of the front legs, and the stretching of the hindlegs. Simplified, and thereby clarified, is also the role played by the small winged horse. Away from the bull, it is now related to the horse alone and clearly defined as the psyche, which emerges from the wound as did Pegasus from the corpse of the Gorgon.

In the compressed space of the picture plane the horse appears face to face with the light-bearing woman. This dialogue ties the theme of the light rather narrowly to that of the lamenting horse. However, by her small size and her place in the architecture, the woman is actually so far removed from the front scene that her determined gesture spends itself in the background without aim when the composition is viewed three-dimensionally.

As in the final mural, the detachment of the bull on the left has its counterpart on the right. The aloofness of the warrior's head makes antagonistic partners of the bull and the dead man with the classical helmet. The self-contained agony of the horse is displayed between two poles of indifference—hardly a suitable presentation of the subject. The head of the dead man, which will finally be directed toward the bull, faces here a large area, occupied insignificantly by an oxtail and an empty window. And in the figure of the light-bearing woman, one arm awkwardly protrudes from the nose and gets tied to the edge of the roof whereas the other sprouts from a corner.

Much organizing remains to be done.

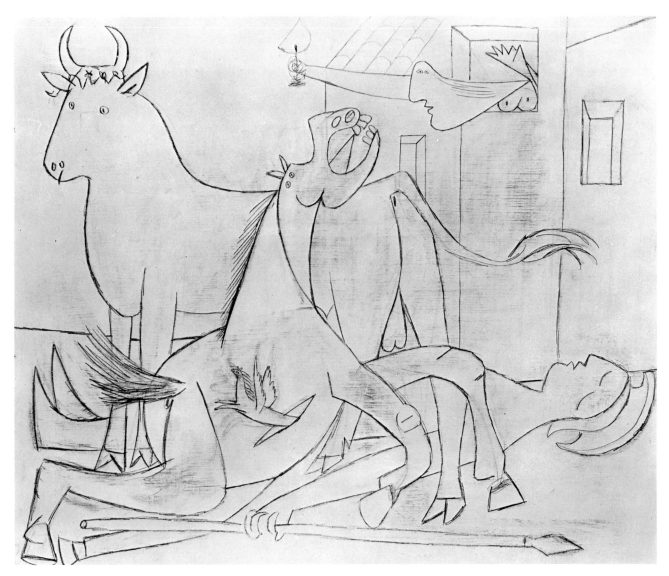

6 *Composition study* Pencil on gesso on wood. 25½″ x 21⅛″. Dated "May 1, 37"

7 and 8

To turn from the whole composition to a detail can be useful in more than one way. It may remove the artist's attention from a pattern that jelled prematurely and thereby blocked the organizing sense for the time being. It also may lead, in a detail, to a solution that becomes applicable to the whole and thereby suggests a way of proceeding further with the total task.

The head of the horse is a crucial element. It embodies the theme of the outcry, not limited—as will be shown shortly—to the horse but to be entrusted also to the human head. The two sketches look almost identical at first glance. To come to realize the progress from the first to the second drawing is good training in visual thinking.

In sketch 7, a huge head overtaxes the strength of the supporting neck, and the top of the upper jaw, with its crown of teeth, outgrows, in turn, the head, of which it is to be a part. The centrally important cavity of the mouth is squeezed and bypassed by the axis of the total shape. By comparison, sketch 8 has more unity. In shape as well as in the distribution of weight, the parts are better fitted to the whole. The neck has become larger and heavier, the head more compact. Consequently, the head is now reduced in emphasis to the extent that it can serve as the upper end of the pyramidal shape of the horse. The lower jaw no longer sags, and the area of the nostrils no longer deflects the central curve initiated in the neck. The upper teeth have been called back to their legitimate anatomical place, where they contribute to creating a symmetrical pincer movement. The vise of the teeth greatly strengthens the push of the tongue, which now breaks the barrier instead of running into the upper jaw. The tongue has become truly the top theme of the whole pattern, whose upward thrust it repeats in miniature. The geometrically simple, piercing wedge of the tongue breaking through the confining cavity is an abstract summary of the total dynamics embodied in the horse and indeed in the central theme of the entire composition.

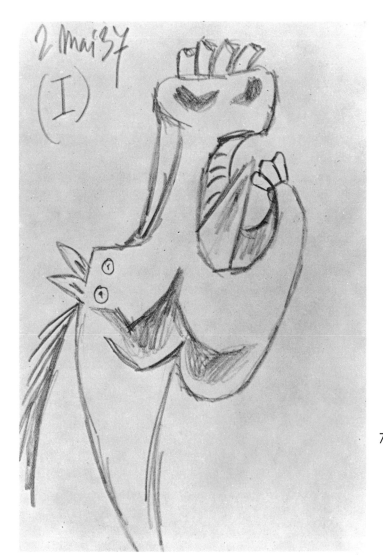

7 *Head of horse* Pencil on blue paper. 8¼″ x 10½″. Dated "May 2, 37 (I)."

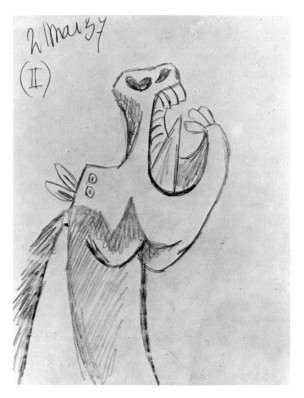

8 *Head of horse* Pencil on blue paper. 6″ x 8½″. Dated "May 2, 37 (II)."

9

Any part of a whole must remain incomplete in its meaning and form. It must be in need of the whole. Otherwise it will be self-sufficient and closed—a foreign body, which can do without its environment and therefore cannot endure it, since art must exclude everything that is not necessary. If the horse's head has become capable of expressing, by itself, the aggressive outcry of suffering, it can no longer tolerate the company of the cast of *Guernica* characters. Nor can *Guernica* tolerate it. The head must be reduced to its partial function.

However, this is difficult, once an artistic concept, capable of independent life, has come close to realization. It cannot be suppressed without the risk of its interfering with the invention from which it sprang. The artist, as our language wisely says, has to "get it out of his system." Under these conditions, the offshoot may grow into a separate, independent work of art. This oil painting of the horse's head, done entirely in black and gray shades, is what gardeners call a "slip," cut from the mother plant and now a plant in its own right.

It is a curious painting—complete but then again not complete. Whereas in sketches 7 and 8 the sheet of paper paralleled the vertical axis of the subject, the painting balances the verticality of the subject with the horizontality of the canvas. But the empty canvas alone cannot do the balancing, and the result is a rectangular pictorial space into which a horse's head reaches rather accidentally. One suspects the horse of continuing outside the frame because the composition is not complete. Thus, the emancipation of the partial theme has been achieved, but not entirely.

The painting closely resembles the sketches made on the same day; but, whereas sketch 8 reduced the weight of the head in order to make it a fitting terminal of the upward-reaching figure of the horse, the head becomes the dominant and in fact the exclusive subject of the oil painting and is therefore enlarged and placed on a low base.

If the horse's head epitomizes the suffering of *Guernica*, why was it not permitted to replace the entire composition? Probably because *Guernica* was to be more than a symbol of suffering. It required a variety of reactions to the assault; it had to relate the contingency of the brutal violation to the inviolable persistence of the spirit of Spain, and it had to add the theme of enlightenment. The mural is an intricate tissue of thoughts, not a mere outcry. If any work of art was ever the "transmission of an emotion," *Guernica* is not it.

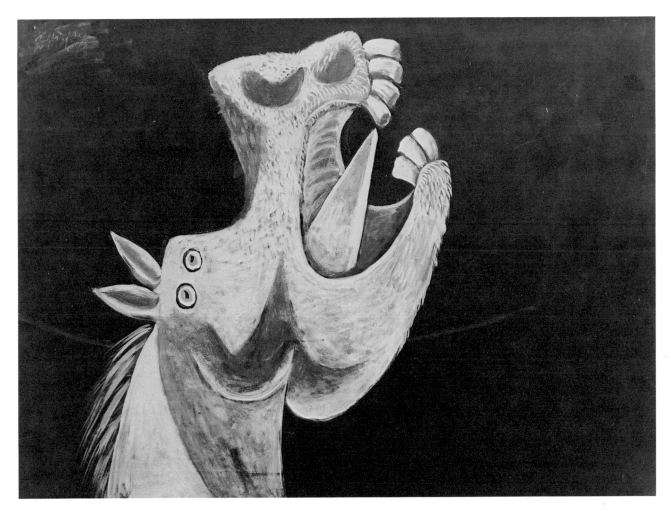

9 *Head of horse* Oil on canvas. 36¼″ x 25½″. Dated "May 2, 37."

10

Done on the same day as the heads of the horse—either before or after them—this new attempt to outline the total work progresses considerably beyond sketch 6. The cast of characters is pulled together: neither the bull nor the dead soldier remains an indifferent outsider. Radical steps have been taken to eliminate the intertwining of limbs. The bull's leap serves the formal purpose of lifting him bodily above the rest of the scene. His outline is entirely unbroken. Also he has become most active; but does the action suit the purpose? Is he running away from the light, similar to his predecessor, the bull-man of the *Minotauromachy*, who shielded his eyes with his hand? Or is he inspired by it? The light-bearing woman has been retrieved from the background. But her exclusive interaction with the bull seems no more appropriate than was her equally exclusive connection with the horse in sketch 6. It is as though the painter were trying out the possible pairings one by one.

If this were the final composition, the simplest interpretation might assume that the bull is the enemy, frightened away by the spirit of light after riding roughshod over the horse and the human victims. In fact, no wounds or projectiles indicate here that the destruction is caused by any other aggressor. Did Picasso waver in his concept of the bull? In the final mural, the steady frontality of the bull's glance is modified by a profile turn of the head, as though the animal, while steadfast, were also shying away from the scene. Is that subtle final gesture a remnant of the straightforward flight from revelation displayed in the present sketch?

The figure of the light-bearing woman is an impressive demonstration of visual problem solving. From one drawing to the next, the painter has attained all but the final solution. The static horizontality of sketch 6 has been changed to a goal-directed downward swing. The stiff stump of the arm has been freed from its tie to the architecture: its shape has been lengthened, and enriched by animating swellings. Lamp and fist, considerably more substantial, have been moved to their central location. The squeezed head has become a full, compact volume, and the stray arm has been clipped off. The bull's tail, a mere space filler in sketch 6, has been assigned the temporary task of playfully accompanying the forward thrust of the woman.

The horse is bent out of the bull's way. This visual simplification considerably affects its role, which now becomes that of the collapsing victim, bowing to fate and engaged in close dialogue with the soldier, the representative of death. The horse has joined a passive mass of vanquished bodies—a defeatist turn of thought. There is still considerable confusion of limbs in the lower right quarter of the picture. A dead woman has been introduced—the first splitting of the feminine element, which stands now for both light and death. This new woman's function is, however, not yet unique. She appears as a duplication of the soldier, which indicates that he, too, is not yet conceived in his final uniqueness.

There is a beginning, though, in that the warrior has now been decapitated smoothly and symmetrically—a change which announces his transformation into a statue. This fragmentation serves, first of all, to clean up the visual promiscuity. Observe the corridor of empty space it creates for the horse's foot and head! We

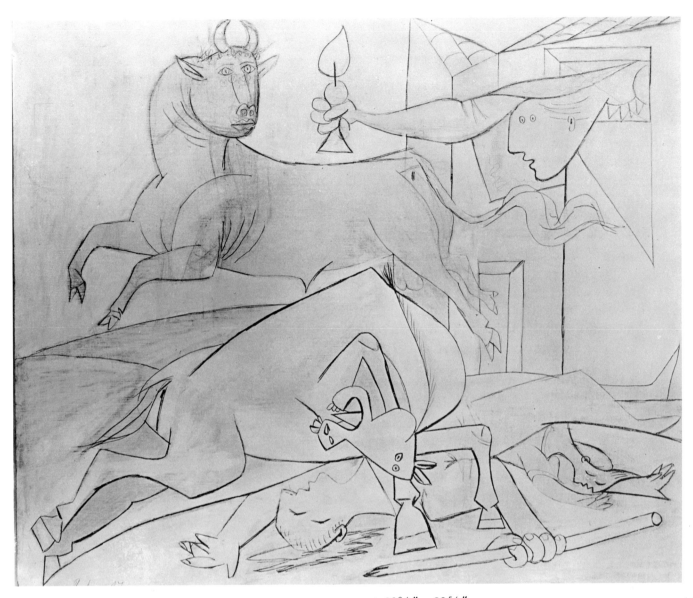

10 *Composition study* Pencil and gouache on gesso on wood. 28¾″ x 23⅝″.
 Dated "May 2, 37."

realize further that a cut-off head of flesh and blood would have appeared as a mere inert leftover from a dreadful physical mutilation. The head of a statue is another matter. Although its place in the picture does make it a product of destruction, a sculptured head is not necessarily incomplete; and it speaks, even when it is only a fragment of a broken marble figure.

The head speaks, yet at the same time the figure is in pieces. Its aloofness is different from that of the bull in the final mural. It is a broken ideal, defeated, out of commission. Being a statue, however, it represents not only material defeat or the pain of it but rather the abstract fact and idea of defeat. Stone does not suffer as horses do. The transformation of the warrior into a statue tempers the heat of the physical catastrophe. It increases the abstractness of the reality level in the whole picture. But even at the more abstract level, the difference between horse and statue remains—the difference between war as organic suffering and as military, historical fact. And while the suffering is alive in the struggling horse, the statue lies dead.

11

Undated but likely to have been done in early May, this leftover from a sheet of sketches may be inserted here. The artist is in an expressionist mood. All shapes are stretched, bent, inflated into bulges, so that they may yield the highest tension. At the same time, all this expression does not seem to be strictly at the service of the idea. The pencil is playing with the shapes, making them into calligraphic flourishes, transforming the bull into an Oriental ornament. To the extent that there is serious purpose in this elegant drawing, it can be said to explore further the theme of upward-directed appeal and the outcry of despair.

The long neck of the horse is better suited for the task anatomically than the stocky bull. If animals, as I said earlier, are used to embody certain human sentiments, they are not selected for their roles only by what we think we know about their mentality but often simply by the external expression of their bodily shapes and movements. Is the swan prouder than the owl? Are there better reasons than purely perceptual ones to use the horse's long neck for the representation of any reaching beyond the present state: the escape from suffering, the longing for salvation, the appeal to a distant helper, the rising above the common ground? In visual thinking, appearance makes for essence, and therefore the horse can yearn better than the bull.

This horse is drawn more realistically than its predecessors; but whereas the shapes are more faithful to anatomy, they convey less directly the telling perceptual properties of the gaping cavity of the mouth, the vise of the teeth, the shooting wedge of the tongue. Here the artist relies on the more indirect expression of traditional drawing, which requires that the observer decipher the perspective projection of the three-dimensional object before its expression can affect him.

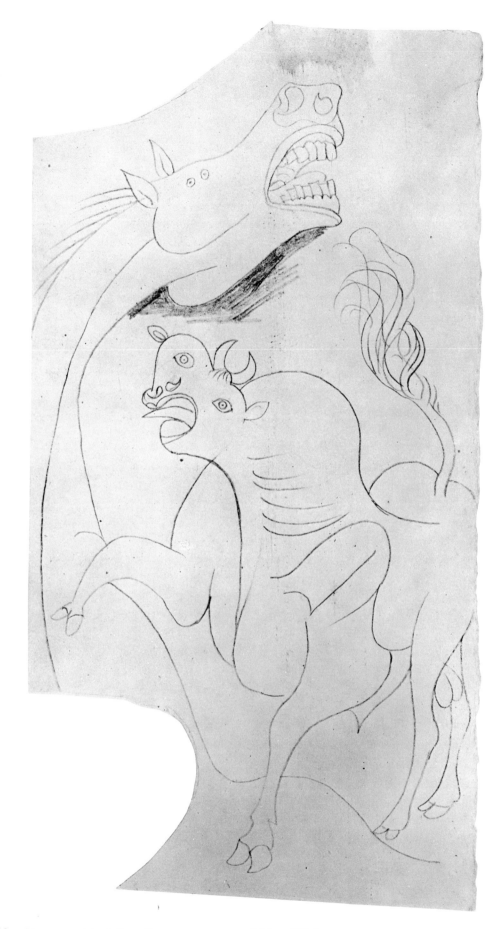

11 *Horse and bull* Pencil on tan paper. 4¾″ x 8⅞″.
Not dated.

12

After a week of experimentation this drawing, although relatively small, is the first to display the monumentality of the mural. Also its ratio (1 to 1.8) is the first to approach the shape of the final work. But the composition is still quite different from the one that will prevail in the end.

The scene is conceived as an arrangement of three relatively independent clusters. The painter's mind, in order to survey its task, neatly segregates essential components of the invention. The bull is now established as holding the background. However, he has been made large enough to serve as a foil for the entire foreground action, which means that he has temporarily expelled or absorbed the function of the light bearer. The bull alone, proud and stable in his pronounced horizontality and verticality, furnishes the reassuring framework of permanence. In fact, the tail of the bull, at first drawn to wave like a flag over the head of the woman—as can still be discerned from the pentimenti—ends by adopting the role of the light-bearing arm. It cannot replace the weighty symbolic meaning of arm and lamp but it does preserve the leftward-directed push, which is evidently an indispensable element of Picasso's visual concept. The more radical gallop of the entire animal in that direction (sketch 10) has been abandoned. Even so, the position of the bull still keeps his hindquarters prominently in the center—an unsolved problem.

The second cluster is made up of horse and warrior—that is, the horse's concern with suffering and death is now complete. Not only is the horse unaware of the bull's comforting presence, it is now separated from him even spatially. This tidy division of themes is too simple to fit the final solution. Bleeding from a wound and bowing its head, the horse nevertheless avoids the total collapse of sketch 10. The straightened front legs and the raised torso now represent the element of stability in a group in which the bull is no longer directly influential. There is confusion in the horse's hindlegs, but a radical attempt has been made to straighten out the intertwining of limbs by isolating the body of the dead man more completely. This makes the unity of the frontal scene rather tenuous: horse and man are barely hooked together. The correct ratio of connection and separation remains to be worked out.

The warrior's head seems to be broken off, but no edge of the neck is visible and the notion of the statue has vanished. The prostrate man has the organic completeness of a corpse.

Perhaps the light-bearing woman was suppressed because the appearance of a new female figure of great significance eclipsed her temporarily. It is as though the splitting of the female element into several figures was not yet accepted in Picasso's mind, and therefore the woman could only be transferred, not multiplied.

Since we know that the mother with the dead child will finally be placed below the bull, we are particularly sensitive to the futility of her present passionate appeal,

50

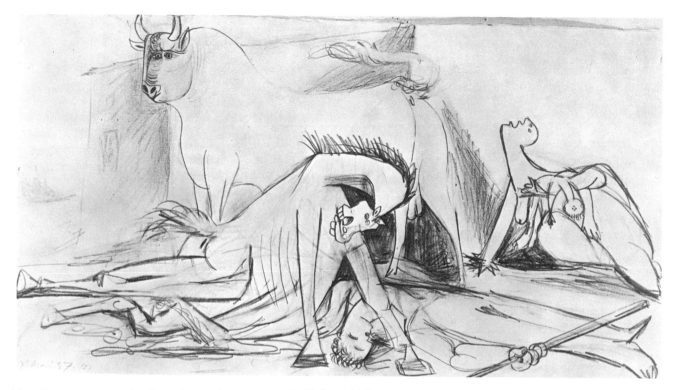

12　*Composition study*　Pencil on white paper. 17⅞″ x 9½″. Dated "May 8, 37 (I)."

which evaporates into empty space. So far she is an afterthought, an addendum, not yet a part of the scene. In her present shape she profits from earlier inventions and foreshadows later ones. The upraised head with the open mouth and the elongated neck had been assigned to the horse, but are now transferred to the mother. The head also anticipates that of the falling woman, which will appear in the same shape and place on the final canvas. Further, the dynamic, forward-leaning triangle into which the woman is fitted prepares the shape for still another feminine figure: the fugitive, who will find her place in the mural without the child and much more closely fitted into the group.

The combination of mother and child will require much organizing. Thus far, the group of the two figures is not adapted to an integrated contour. The elbow of the left arm, which holds the child, sticks out and creates a shallow horizontal depression, an interruption of the outline's dynamic descent. The plump mass of the left leg is equally unassimilated. The right arm, an externally attached support of the body, restrains a loose arrangement of breasts, hands, and baby legs. The child's head, in shape and location a reminder of the mother's genitals, from which it emerged, is still schematically circular and without any action of its own.

13

Later on the same day the painter singles out for further study the figures of the horse and the mother. This helps us to realize how closely related the two themes were in sketch 12. They were almost mirror images of each other. The same leaning triangles of the over-all shapes, the same support through front legs and arm. The comparison even tempts us to think of the head of the dead soldier as the opposite number of the dead child. In fact, thus far the functions of the two themes are almost identical, which means that their distinctive relationship has still to be worked out. The mother has been shaped in the image of the horse: shall she remain a duplicate or acquire a role of her own, or shall one of the two be eliminated?

A tempting answer, which would advocate a decision of great consequence, is suggested by the counterpoint of downward glance and upward glance in the two parallel themes. This counterpoint could become the core of the entire composition, which might then place the story of violence between the downcast attitude of despondency and the appeal to the powers above. A strong religious element might thus have been introduced. Significantly, this concept did not prevail. In the final mural all faces are oriented toward the bull—that is, toward earthly salvation rather than toward heaven. Even in the falling woman the upward glance is effectively contained by the window and the boundary of flames, and overpowered by an irresistible descent.

The downward turn of the horse's head, closely copied from sketch 12, is not final. The figure of the mother is remarkably perfected. The triangular boundary has been tightened: hair and scarf close the gap behind the head, a wing-shaped coat sharpens the movement, and a clearly established base terminates in the foot, which will mark the lower right corner of the final mural like a full stop. The supporting arm is pulled in, and the internal arrangement of shapes is tidied up and organized. The child's head, as though still half unborn, is enclosed in a diamond-shaped, shaded cavity; and although the child continues to show vaginal connotations, it is now animated by an alarm of its own. Two ripe breasts, ready to offer nourishment, rest on the baby's body yet are separated from it by dark blood.

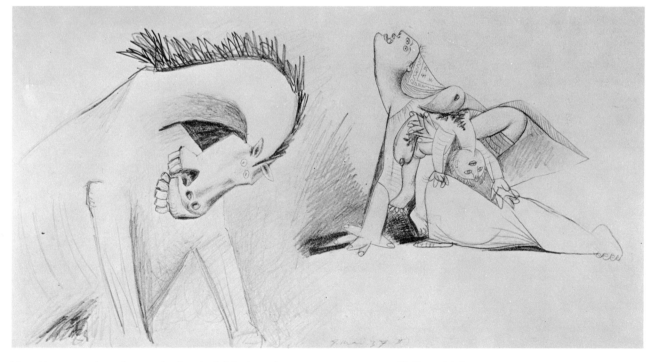

13 *Horse and mother with dead child* Pencil on white paper. 17⅞″ x 9½″.
 Dated "May 8, 37 (II)."

14

Another attempt, on the next day, further tightens the triangular figure. The mother's head is pulled back so that the neck, together with the right arm, forms a sturdy vertical. The sprawling breast and elbow are withdrawn from the contour area, and help to organize a compact internal nucleus of shapes. The child's head has, as it were, emerged from the womb; it now marks the center of the whole pattern, the focus of greatest intensity. The child is pulled together, more frantically hugged, and the over-all result is a considerable intensification of expression.

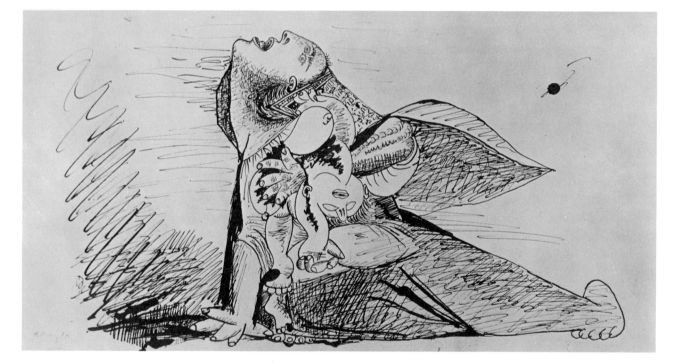

14 *Mother with dead child* Pen and ink on white paper. 17⅞″ x 9½″. Dated
"May 9, 37 (I)."

15

What an abundance of shapes in a drawing no larger than the preceding one! Of all the presentations of the total scene, this goes farthest in spelling out three-dimensional architectural space. It comes closest to depicting realistically a physical war scene. It is also the most confusing.

The background is slashed by many black and white wedges, formed by corners of perspectively foreshortened walls and roofs, but also and mostly by triangular shadows. These shadows are sharply outlined, as though the scene took place on a planet without atmosphere, and tend to detach themselves from the objects and to populate the picture plane with independent, aggressive pointers. They survive in the final mural as one of the most characteristic perceptual qualities of texture, broken, however, by transparency effects, which replace the stark alternative of black and white with more temperate shades of gray.

The bull, muscular and tangible, still maintains the central position he held in the earlier sketches. But he now clearly displays that ambiguity of attitude which will distinguish him to the last. The back of his body is going, the front with the head is coming. The eyes look threatening. Again, as in sketch 10, he may give the impression of the triumphant destroyer. But has the light attracted or annoyed him, or is it deterring him? Is the woman with the light appealing to him, trying to see him clearly, or trying to frighten him away? It seems fair to conclude that Picasso himself was not sure of the answer. Since the artist thinks by means of the shapes he creates, he is not likely first to define his ideas neatly in the abstract and later to search for the proper form that will make them visible. He will rather try to determine what he is thinking by experimenting with forms that will show his eyes the consequences of various thoughts. Chances are that the image of the bull gradually clarified its meaning by shedding initial negative connotations and by withdrawing from an active role in the center of the composition.

The creative process has systolic and diastolic stages. The artist condenses his material, eliminating unessentials, or he draws an abundance of shapes and ideas, recklessly crowding the concept. Rather than grow consistently like a plant, the work often fluctuates between antagonistic operations.

Sketch 15 is a product of diastolic exuberance. Doors and windows, stray arms and fragmentary corpses clutter the picture stage and make it look a little like a typical artist's studio, where disorder serves to supply plenty of raw material and freedom for invention. If the bull is to stay where he stands, yet show the fundamental columns of his front legs, the horse must be moved away. Its bent neck and head remain in position, but the body is shifted to the right—an expedient tried for the warrior in sketches 10 and 12. However, this move weakens the center, at which a wheel is introduced temporarily. The powerfully simple shape of the wheel seems to be an attempt to create order by means of a central pivot. It also separates the horse from the bull by depriving the latter of his hindlegs.

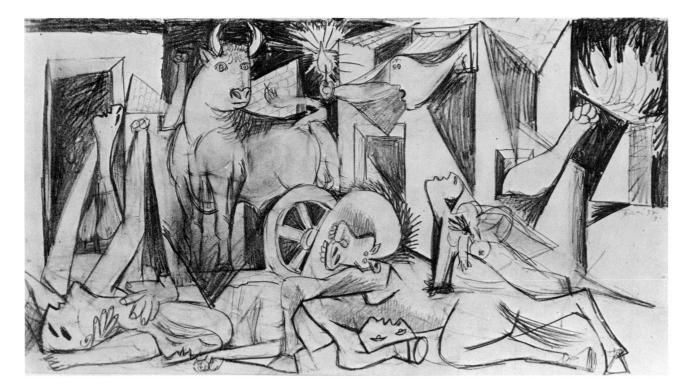

15 *Composition study* Pencil on white paper. 17⅞″ x 9½″. Dated "May 9, 37 (III)."

The mother with the child has moved from the extreme right to the place which a woman patterned after her will finally occupy in the role of the fugitive. However, this achievement leaves the right flank of the picture again uncovered. It also causes a clash between the woman and the horse's body. The triangular female figure of sketch 14 is destroyed by overlapping, and the supporting arm pokes insecurely into the horse's soft belly.

The theme of the appeal to higher powers is not yet abandoned. It is reduced here to the almost abstract form of unattached arms sprouting from the ground cover of corpses, from the window behind the bull, from the window above the mother. These arms lack an organic base, just as the idea for which they stand is apparently not rooted in the central concept of the work. They are fillers seeking full status. In the preparation of the final canvas a last, impressive attempt will be made to grant the raised arm a central position.

This is the last sketch for the total work. Two days later, the outlines are drawn on the final canvas. Sketches of details continue to be made while the mural itself takes shape. Unfortunately there seem to be no dates to indicate when the various states of the mural were reached. Nor do we know on what day it was finished. This makes it impossible chronologically to coördinate the later sketches with the work on the painting. I shall have to deal with the preparatory stages of the canvas after the sketches, and limit the coördination to occasional references back and forth.

16

In sketch 15 a new female form, prefiguring the mother in her final location, appeared on the extreme left. Her presence gave emphasis to the emptiness of the corresponding space on the extreme right. Who or what is to fill the space occupied only by a fire, a fist, and bits of architectural geometry?

Sketch 16 suggests the idea of the mother escaping from the burning building on a ladder. The motif of the ladder is, as I mentioned earlier, reminiscent of the *Minotauromachy*, where a bearded figure occupies the extreme left of the print (that is, the extreme right of the image Picasso engraved on the plate.)

The mother descends the ladder to escape from the burning house. The need for downward movement on the right has been discovered, but mere descending will be too weak a counterbalance for the bull of *Guernica*. The extreme descent of the falling woman will finally supply the needed intensity.

But even the mother's descent is close to a fall. The conspicuous enlargement of the thigh lowers the center of gravity and transforms the organ of locomotion into a part of the inert torso, which hangs downward from—that is, "de–pends" on—the center of action. Like the large body, the heads and the baby limbs sag. The panic has changed active, voluntary movement into passive dropping, a lifeless submission to material weight. Verticals and horizontals—the least dynamic directions—determine the pattern throughout. The reduced tempo of action is expressed in the central theme; the sluggish flow of the blood, which moves from the neck wound almost without descent, fuses with the contour of the child's arm, and dries up after oozing through the spaces between the mother's fingers.

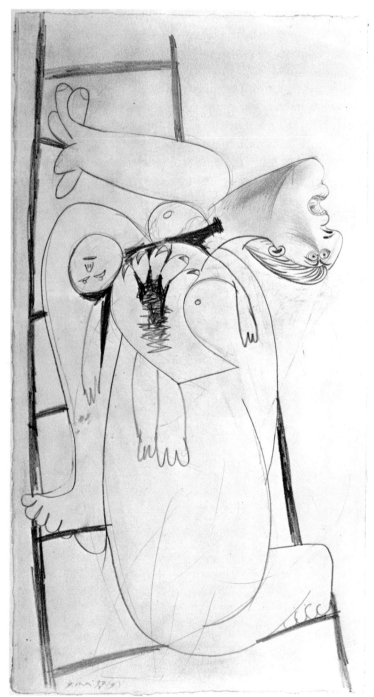

16 *Mother with dead child on ladder*
 Pencil on white paper. 9½″ x
 17⅞″. Dated "May 9, 37 (III)."

17

Free from the interferences of its neighbors, the horse gives perfect shape to the theme of collapse. Compared with sketch 5, done ten days earlier, sketch 17 is more limited in that it renounces almost entirely the interplay of upward striving and downfall. Only the left hip, a minor part of the body, rises to a visual climax, with a few hairs of the mane replacing the eloquent mouth, eyes, nostrils. Yet here, as in sketch 5, the fall is spelled out dynamically by the various phases of collapse in the legs. Kicking upward feebly, the right front leg is checked in its thrust by the grandiose arch of the neck, which carries the head all the way to the final contact with the ground. The neck traces the complete curve of the downfall. The meeting of head and hoof is a meeting of the extremes—of the crown of the animal and its lowest base—the visual definition of total collapse. This coincidence of head and hoof will be represented in the final mural by that of the warrior's head and the horse's hoof. The formal motif, here invented, will survive but will be portrayed by a different member of the cast, and the contrast between the hero's head and the animal's foot will make the fall even more complete.

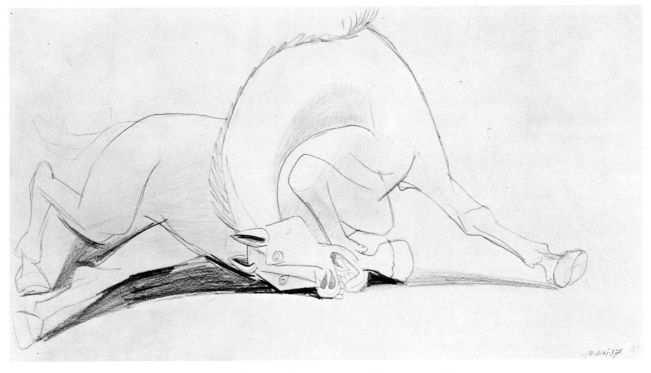

17 *Horse* Pencil on white paper. 17⅞″ x 9½″. Dated "May 10, 37 (I)."

18

The second drawing done on this day further explores the nature of those two extremities—the head and the leg—whose encounter marked the ultimate of violent dislocation. The faithful portrayal of the leg serves to recall the anatomical base, which must remain perceivable even in radical deviation. In fact, when the artist simultaneously presents the norm base and the deviation from it, a most effective tension is created. This device was hardly applicable in older, more realistic art. Picasso—as the drawings of the heads show—can combine a frontal eye with a profile eye, and thereby not only define the deviation through reference to its base but also obtain the squeezing effect that results from the perceiver's effort to reconcile the two aspects in one image. The same is true for the contradictory placing of the nostrils; and the dislocation of the lower jaw in the upper sketch not only represents the gnashing of the teeth but is also the visual coincidence of two different spatial orientations, with the ensuing tension between the two positions of the same object.

The modern artist has reacquired a privilege of primitive art: that of being able to show what is relevant even though hidden from sight in the model. The powerful bone of the jaw is given a chance of strengthening the contour, and the cavity of the mouth with the aggressive tongue is revealed as though by section. These revelations of the invisible strike the perceiver so violently because the style of the drawing is otherwise close to realism. Within the more abstract style of the final mural, the revelation of the mouth is "normal"—that is, not in the nature of a purely local distortion. In consequence, the horse's head in the mural looks less frantic.

A curiosity: the leg seems to have been drawn last. The artist is unlikely to have pushed the object so close to the left border if he had had an empty sheet of paper at his disposal. Did the narrow area of somewhat bent shape, remaining after the two heads had been drawn, suggest the addition of the leg? If so, we have here a welcome example of the interplay of suggestions deriving from material conditions— often by accident—and the requirements of the task. The empty space suggested a leg, because the confrontation of head and leg was demanded by the present stage of the problem. But, without the vaguely leglike shape of the remaining space, would the leg have been drawn?

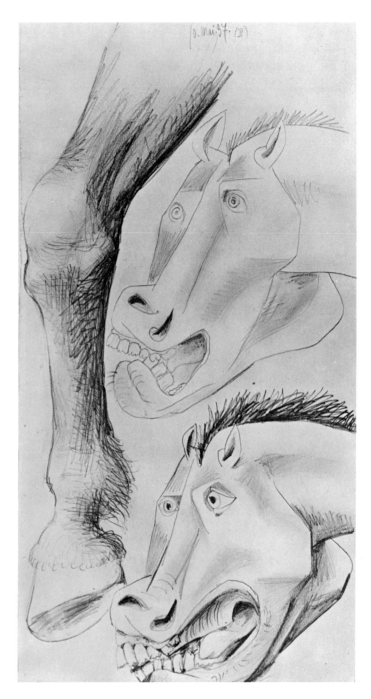

18 *Leg and head of horse* Pencil on white paper.
9½″ x 17⅞″. Dated "May 10, 37 (II)."

19

Perhaps it was this first close-up of the bull, done at the time when Picasso began to outline the figures on the final canvas, that committed the painter definitively to a concept of the animal as an ideal, benevolent power. His statement is quite radical; it will be toned down later, in keeping with an over-all style that excluded classical beauty.

In spite of the lateral foreshortening of the face, the symmetry of the features is unimpaired. All symmetry expresses a state of perfection, which does not admit of any change. Nor do the features tell of tension or disfigurement. All curves have an impeccably normal shape. The face is essentially human—indeed divine. It is bearded and woolly like that of the creative artist in Picasso's earlier work. No doubt, a standard of integrity, virtue, and natural power is firmly established.

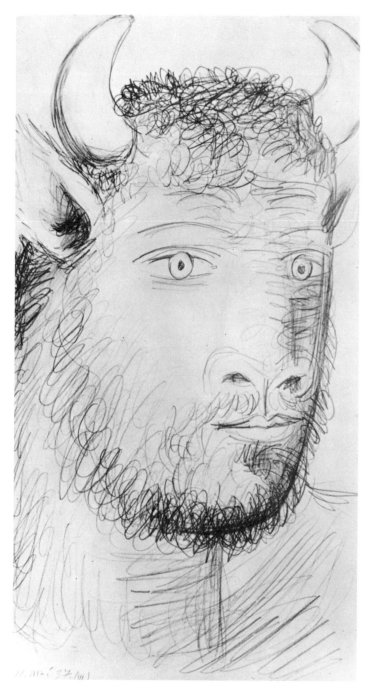

19 *Head of bull* Pencil on white paper. 9½″ x 17⅞″.
 Dated "May 10, 37 (III)."

20

The frontal part of the horse's body—particularly its head and neck—have sustained the expressive role of the animal rather independently and dominantly. Here, head and neck maintain their orientation, except for rising from the ground, whereas the body is switched over to the right side again. At the same time, there is a stylistic transformation. The shapes are simplified geometrically, and the shadows no longer derive only from the volumes they are intended to help create, but become self-contained, sharply defined triangles or prisms. This reduces the image of a three-dimensional material body to a pattern in which shapes tend to dominate the represented object. Presumably, the use of color crayons in the drawing serves the same aim. The ground is bright yellow, the triangle behind the leg is green, and there are vivid purple and blue shades in the head.

This tendency may be described as a search for a level of abstraction appropriate to the correct relationship between material event and idea in the presentation of the *Guernica* story. Again, we should not assume that this ratio was already settled in Picasso's mind and that he was now busy casting about for a style in keeping with that preëstablished notion. Rather, the artist can be expected to have tried to find the reality level of his presentation by experimenting with various ways of giving shape to bodies and other objects and waiting for his eyes to tell him that the picture looked right. This judgment, then, would not refer to a purely visual appropriateness but to the correct relationship between the patterns seen and the meaning intended.

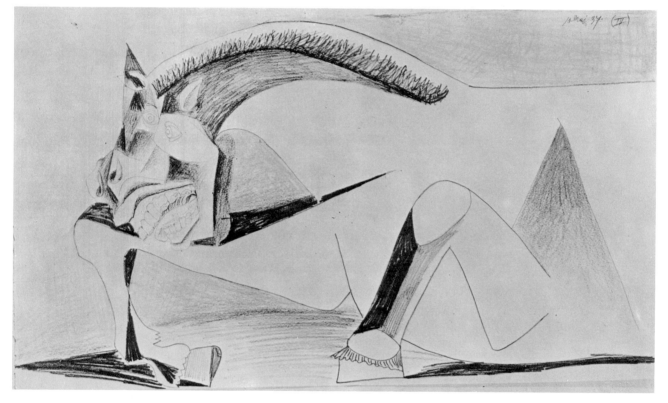

20 *Horse* Pencil and color crayon on white paper. 17⅞″ x 9½″. Dated
 "May 10, 37 (IV)."

21

The fifth and last sketch of May 10 closely follows sketch 16, done the day before; but an almost violent attempt is made to destroy the informative outlines of shapes and the volumes defined by these outlines. The figures are made less solid, less material, less complete. Whereas the objects are broken up, the surrounding empty space is filled with abstract shapes—a cubistic device by which the basic distinction of tangible object and intangible environment is abolished. The drawing is very brightly colored.

There is considerable evidence to show that the modern artist often arrives at the final style of a work by way of an earlier more realistic concept. Picasso himself described this process clearly in an often-quoted statement: "In the old days pictures went forward toward completion by stages. Every day brought something new. A picture used to be a sum of additions. In my case a picture is a sum of destructions. I do a picture—then I destroy it." This procedure should not be interpreted to mean that the modern artist artificially disfigures the natural appearance of an object. But novel it is indeed. To be sure, even in older art there are minor differences of style between preparatory stages and final composition. However, they are minor, and derive largely from the difference between a quick notation of what is observed in nature and recorded with pencil or pen and the slow elaboration of the definitive image in a more momentous technical medium. The modern work often undergoes a fundamental transformation of style, which may indicate that here the spontaneous pictorial equivalent of a visual experience is not identical with the form needed to convey the definitive meaning of that experience. The woman on the ladder has to change reality level in order to tell what she is intended to express.

The destruction of realistic shape is selective. The mother's face—the principal carrier of the psychological theme—is least affected. The huge volume of the enlarged thigh, outlined at first, is hidden entirely under dark, abstract shapes, and gone with it is the emphasis on the dead weight of paralyzing fear. Now the statement concentrates on the mother's reaction to the catastrophe and the lifelessness of the child, on the contrast of drooping limbs and grasping arm and the significant formal parallel of the live breasts and the similarly shaped and sized dead head of the baby.

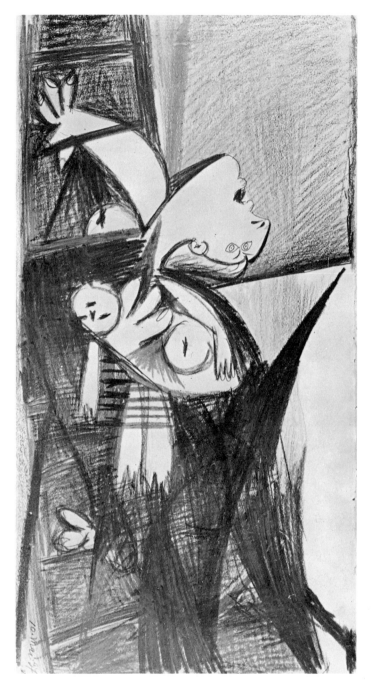

21 *Mother with dead child on ladder* Pencil and color
crayon on white paper. 9½″ x 17⅞″. Dated
"May 10, 37 (V)."

22

The Greek serenity of the bull's face is carried to an extreme. Almost completely frontal, it is no longer framed by woolly hair, and all features are distinctly human. The nose is classically straight, and the entire figure is fitted into a framework of stable horizontals and verticals. Outlines are made of straight lines or simple curves, and the four legs stand on a plane base, supporting the monument like a pedestal. The mythical centaur can be described as the opposite of the Minotaur. Rather than a man with an animal head, it is an animal with a sublimely human head—that is, instead of a human being propelled by beastly instincts, we see nature refined to the highest state of humanity. The light falls from the left—a place for which the total composition of the mural provides no light source. Placed in a setting explicitly described as empty space, this figure seems to have been created without any specific reference to the context that suggested it.

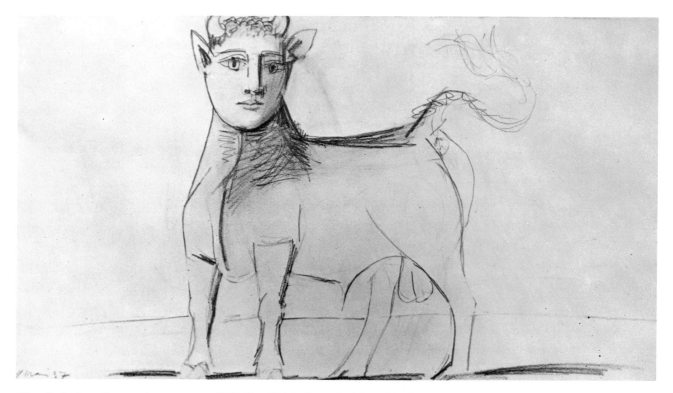

22 *Bull* Pencil on white paper. 17⅞″ x 9½″. Dated "May 11, 37."

23

Earlier, the outcry embodied in the horse's head was treated in a separate oil painting (sketch 9). But the compelling and bothersome autonomy of that theme has not yet been overcome. Here it has changed carrier again. The part is taken over by the woman, in keeping with the early stages of the canvas itself, on which the painter is working at approximately this same time and in which the horse's head is bent down while the two female figures flanking the mural raise their crying faces almost identically. The detail reproduced on this page shows the mouth of the mother in the final mural.

Horse or woman, the vehicle is still of only secondary importance. The true actor is the mouth, presented with an almost obsessive attention to the realistic details of wrinkled lips, grooved palate, jagged teeth, and the papillae of the tongue. Is grief to be expressed by the material presence of the afflicted body or by the perceptual dynamics of abstract shapes? This drawing has no consistent reality level. The ear has been reduced to the simplest geometry, and the nostrils and eyes are elegantly ornamental, indicating that the artist is withdrawing from the object in a playfully searching mood. The bright yellow background in combination with the blue hair and the green dress also indicate some detachment from the task of preparing for a monochrome painting.

The closeness of the eyes expresses tension. This effect is brought about not by the visual pattern in itself but by its deviation from the normal distance between the eyes, of which the perceiver knows. The interplay between the normal spacing of

23 *Head of woman* Pencil and color
crayon on white paper. 9½ʺ x
17⅞ʺ. Dated "May 13, 37 (I)."

facial features, recorded in the perceiver's memory, and the shortening of the distance
in the drawing produces the sort of dynamic effect on which almost all expression of
face and gesture is based. Such deformation serves its purpose, no matter whether
it is realistically attainable or not. Human eyeballs, fixed in their orbits, cannot
approach each other. Nor can a mental upsurge stretch the human skull in the
vertical. Yet the gain in perceptual expression may outweigh the diminished sense
of material presence.

Every element must reflect some aspect of the total expression. The warrior's hand contributes the grasping of the weapon, which is broken. The drawing makes this grasping rather frantic; it hardly permits us to remember that fingers issue from the palm of the hand in a harmonious star pattern. Here they look like isolated individuals stumbling over each other in a panic—little creatures with their nail heads turned either up or down. A sixth finger helps to increase the crowd. The shapes are twisted or even cracked in the joints. This erratic complexity in the drawing will give way to a simpler, more harmonious wheel shape in the mural. It is as though in the separate drawing hand and sword were made to carry a central mood of *Guernica* by themselves, whereas at its place within the whole the function of the detail became more specific. In the mural the converging fingers of the grasping hand are the contrapuntal opposite of the spread-out left hand—a symmetry of opposites, similar to that of bull and falling woman. Contraction is disavowed by release, concentric action by *rigor mortis*.

The hand in sketch 24 is more than a fragment of the whole. It is not related to a partner. Like most of Picasso's studies, it has an independence of its own. Hand and sword are presented frontally, not receding as the requirements of the mural will make them appear finally. Here again, as in the figure of the bull in sketch 22, the larger context does not seem to influence the concept of the detail. Every Picasso sketch, like every finished work of his, is a bead in a chain: it is complete and incomplete at the same time.

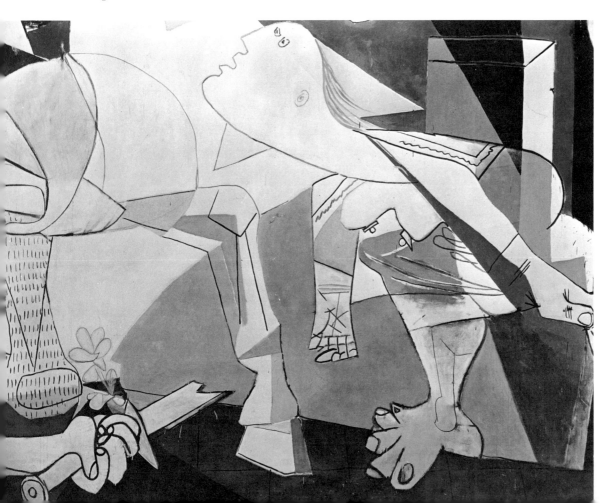

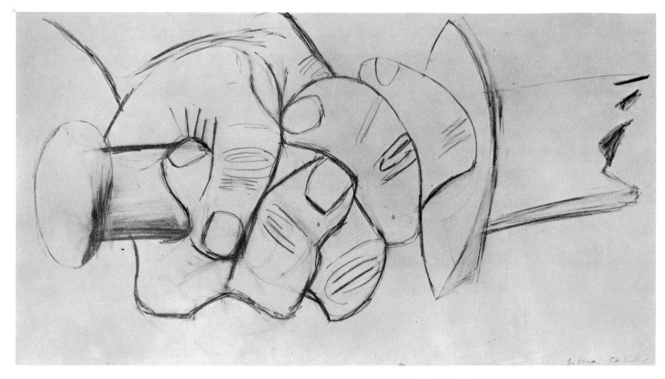

24 *Hand of warrior with broken sword* Pencil on white paper. 17⅞″ x 9½″.
 Dated "May 13, 37 (II)."

25

This study of mother and child is difficult to decipher. The dismembering of the bodies, interpreted in sketch 21 as a device of breaking away from realism, is carried even further. The group is vaguely combined with bits of brightly colored architecture, but more for the sake of giving the study some completeness in itself than as an indication of its place in *Guernica*. No longer related to the vertically extending area of the burning house at the right side of the mural or identified with the triangular figure of the fugitive, the drawing does not resemble the mother-child group in the final mural either. This is curious because, when the sketch was made, the final solution had already been outlined on the canvas. Did the painter wish to make sure, by means of a distinctly different rendering of the subject, that he was still free to change his mind?

The treatment of the eye calls for comment. What we see is the single eye of the profile duplicated, not a pair of eyes grafted upon a side face. The duplication of the eye is justified by the twofold function it is given: it is small, directionless, and subservient to the dominant outcry of the mouth, and it is also large, sharply focused, actively discerning. The two reactions of perceiving the dead child and crying aloud are not combined in one indivisible expression but, rather, are separated in such a way that they fight with each other for dominance. The result is a most effective ambiguity: mouth and large eye, freed from their organic relation by being placed at the same level and separated also by interposed shapes and shadings, cannot be perceived together but only in insoluble conflict. Screaming fights with staring, staring with screaming—a most appropriate representation of a state of mental turmoil. However, mouth and eye are not compositionally disjointed. They both lie approximately on the horizontal axis of the cone-shaped head, which collects the image of the child like a concave mirror, receiving it (through the eye) and reflecting it (through the mouth).

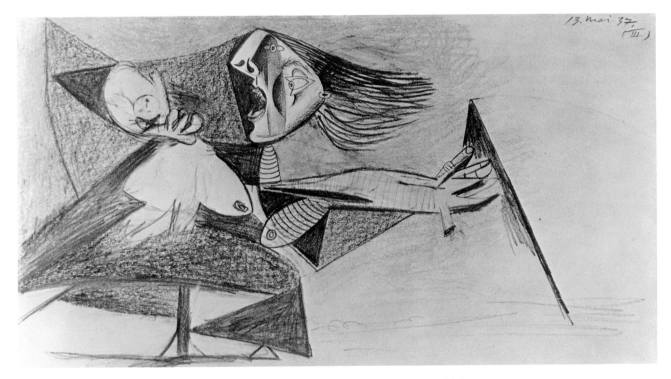

25 *Mother with dead child* Pencil and color crayon on white paper. 17⅞" x 9½". Dated "May 13, 37 (III)."

26

For a week, no sketches had been made, probably because the painter was now working on the mural itself. During that period, separate exercises on paper could serve three purposes. They could help him to clarify specific problems; they could counteract the compelling power of the shapes on the canvas; and they could be variations on a theme already established, explorations beyond *Guernica.*

We left the bull as an image of godlike perfection (sketch 22). He could not remain that unless the entire composition changed to conform to such a style. The present portrait of the animal does not represent a transformation of the bull from Greek serenity to beastly ferocity. What we see now seems to be essentially the same concept of a powerful, imperturbable monument, translated, however, into a more rugged pictorial language. No longer are the features fitted into one smoothly rounded whole. Each organ asserts itself as an individual volume, forcefully expanding and exerting pressure upon its neighbors. The bulging cheek, made substantial by a wash of gray gouache, clashes with the heavy cone of the nose. Eyes, ears, and horns seem to be welded to the head rather than growing from it. The shape of these organs and their behavior toward each other convey the expression of reckless strength. The basic symmetry continues to make the image stable, but secondary deviations from the symmetry introduce tension: the horns are in conflict with each other, and so are the nostrils; the upper lip is displaced against the lower lip. The change from the Greek god is radical. But what has changed is not so much the character of the animal itself as the way of representing it.

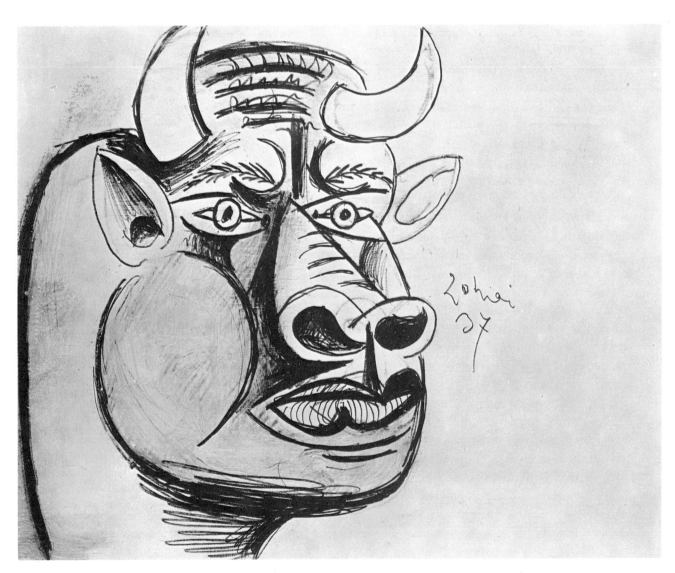

26 *Head of bull* Pencil and gray gouache on white paper. 11½" x 9¼".
 Dated "May 20, 37."

27

Both portraits of the bull were drawn on the same day, but in what order? Picasso fails to help us with his usual Roman numerals. We have no reliable way of deciding between two quite different interpretations. If sketch 26 was done first, we can hardly avoid the impression that after having established a set of forms that suited their purpose the painter lost himself in playful variations, taking off from the image of the eye, surrounding the circle of the pupil with all manner of triangles, ovals, and prisms, and decorating them with sprigs of eyelashes. He dissolved the volumes into pictorial shapes, elaborated on their geometry, and all but lost his object.

Playfulness has always been an important helper of artistic exploration. It becomes dangerous only when it replaces the disciplined, goal-oriented search for significant form. Pictorial playfulness manifests the delight in the variety of visual shape, the elementary affection that every artist has for his medium. But how are we to distinguish playful shapes from those serving expression? There is evidence that when the eye and hand of the draftsman are not directed by an ultimate objective, the visual sense indulges in the easy harmonies of geometrically simple patterns, repetitions, decorations, fillers. The diagnosis is, however, complicated by the fact that in the twentieth century artists have favored precisely such formalized patterns. Was Kandinsky or Klee playing? In every individual instance the judgment of the perceiver must depend on whether he succeeds in deriving from the patterns furnished by the artist a meaning that goes beyond the pleasurable recreation of the eye. A glance at *Guernica* reveals that unimpaired geometrical shapes are rare. Wherever they are used, their visual appearance is clearly determined by their function, such as in the mechanical perfection of the spindle-shaped ceiling light, the steady eyes of the bull, the inorganic eyes of the statue, the dead eyes of the child. The precise rectangle of the window lit by fire effectively contrasts with the irregular shape of the falling woman's head. By this standard, which is that of Picasso's accomplished works in general, drawings such as sketch 27 must be considered melodious exercises, intended to keep the repertoire of shapes well supplied and to preserve the liberty of choice.

If sketch 27 was done before sketch 26, we might be inclined to say that, after searching for an appropriate presentation of the bull in a drawing overloaded with visual suggestions and concerned with shapes rather than meaning, the painter arrived, in sketch 26, at a convincing possible solution. Even in this instance, however, we can hardly overlook the fact that when these drawings were completed the head of the bull had already found its final shape on the canvas—a shape oriented toward the left rather than toward the right and in many other ways quite dissimilar from that of the sketch. At this stage of the work, the accessory drawings can no longer be thought of simply as preparations for the mural. They are accompaniments or even—to use a term aptly applied to them in earlier publications—postscripts.

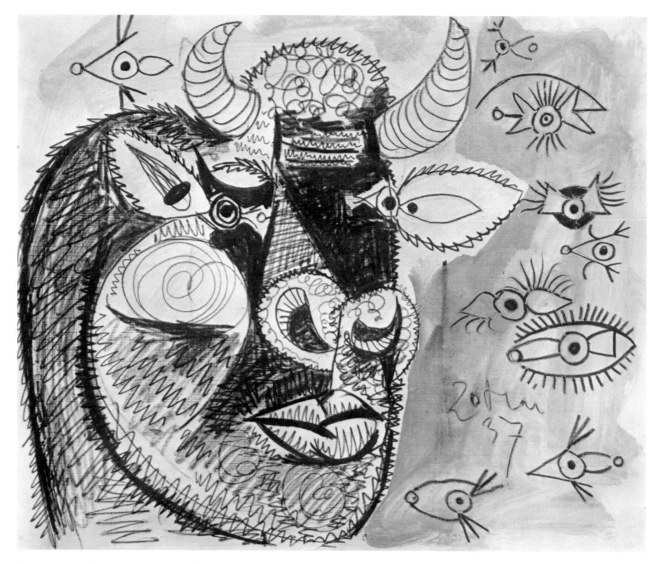

27 *Head of bull with studies of eyes* Pencil and gray gouache on white paper.
 11½″ x 9¼″. Dated "May 20, 37."

28 and 29

These two sketches for the horse's head are more obviously related to the task at hand. Until now the horse had appeared in either one of two attitudes. With its head and neck bent down it was entirely a victim among victims, sharing the company of the dead warrior and devoid of contact with the superior powers of the bull and the light bearer. With its head turned upward, it performed the outcry of despair, appeal, and accusation, more suitably left to the human faces. In the early stages of the mural itself, the horse's head is turned downward; and perhaps it is only with the sketches of May 20, which we are now considering, that an in-between position was finally established.

In the end, the horse's head serves as the focus or crossing point for three compositional contexts. First of all, closely related to the apex of the central triangle, the horse's head represents, as it were, the spokesman of the victims, a compact keystone, as indicated in the squarish shape of sketches 28 and 29. But it also plays a dominant part within a vertical and a horizontal axis of the composition, and the relative strength of these two directions needs to be determined. The vertical, which prevails in sketch 28, establishes the horse's head as the top of the backbone sustaining the triangle; whereas the horizontal, dominant in sketch 29, sets up the lateral motion of the three profile heads, from the light bearer over the horse to the bull.

The two sketches are concerned with the problem of how much of the dynamics of the crying mouth can and shall be preserved in this new, more stable framework of the profile head. We do not know which of the two was done first; but sketch 29 is more convincingly organized and closer to the final solution. In sketch 28 the vertical and the horizontal are explicitly given in two main lines, and in spite of the heavy diagonal of the lower jaw, the head as a whole looks stubby, weak, and static. In sketch 29 the paper is turned sideways, the mouth profits from the dominant horizontal direction, and a balance between stability and dynamic obliquity is apparent: the lower teeth, for example, state the theme of the basic framework, whereas the diagonal upper teeth enhance the action.

When exposed to the compositional forces of the mural, this fairly simple pattern undergoes significant deflections. Pushed out of the way by the central vertical of the lamp, the neck of the horse is bent in the direction of the bull, who is the power beyond the confines of the central triangle. The horse thus establishes the connection between the central group and the bull, breaking with its snout through the diagonal barrier and pushing at the same time against the insensitive horizontal of the ceiling light. This compositional involvement calls for formal complexities not required in the drawings of the isolated head. By itself, the head can afford a simplicity of spatial orientation which would isolate it as a part of the whole. This simplicity, however, makes the pictorial exploration of the head in isolation so useful. To put it practically: one needs to know what a thing is in itself if one is to determine its behavior in the give and take of an environment.

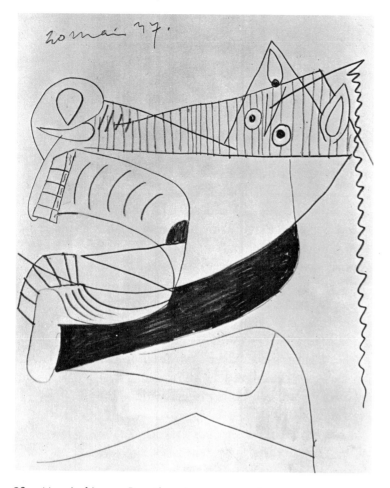

28 *Head of horse* Pencil and gray gouache on
white paper. 9¼″ x 11½″. Dated "May
20, 37."

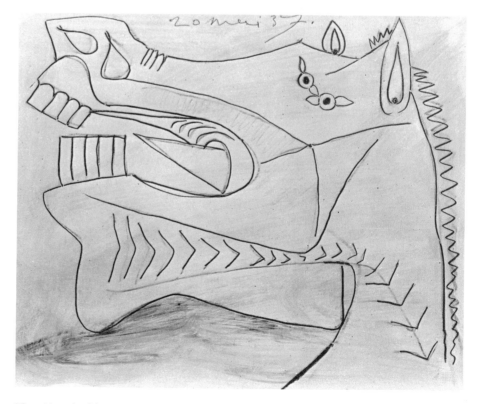

29 *Head of horse* Pencil and gray gouache on white paper.
11½″ x 9¼″. Dated "May 20, 37."

30

The horse's head is no longer involved in the competition as to which member of the cast should be entrusted with which sentiment. Its shape and function are now determined. There remain the human heads, three of which are still in search of their final character. Eventually the head of the mother, the head ot the warrior, the head of the falling woman will all gaze upward. So will those of the dead child and the fugitive. Together, the heads of *Guernica* display the full range of orientations in space.

The child's head, completely upside down, portrays the final immobility. In both the warrior and the falling woman, the round skull pulls the head backward by its weight. There is dynamics, but it is that of the pull of gravity acting upon a powerless body. The light-bearing woman, alive and actively engaged in the events, looks forward. The face of the fugitive is oriented diagonally. Directed by the triangle of the central scene, her eyes are raised toward the light. The mother's profile, finally, is turned so fully upward that it assumes the static position of the horizontal. In her mouth the outcry is at a maximum, but she is also paralyzed by the symmetrical orientation of her head. Hers is a permanent cry, inhuman in its mechanical monotony, not to be stopped by anything at any time.

It is this permanent cry, provided for already in the first outlines of the canvas nine days earlier, which is spelled out in sketch 30. Like all the other profile faces, this one is equipped with two eyes and two nostrils, thereby maintaining some frontality while engaged in the lateral action that takes place in the picture plane. These pairs of small objects serve also to animate somewhat the dead horizontality of the upturned profile. Eyes as well as nostrils are given a teardrop shape, known to the Japanese as "*magatama*"—the curved jewel. This shape attractively combines centric roundness with pointed direction. Whereas the circular eyes of the *Guernica* horse and the spindle-shaped ones of bull and warrior are fairly static, the *magatama* produces a lively crescendo or decrescendo, intensified by the curve of the sharp tail. Through the teardrop shape, Picasso produces openings "with a swing to them." Occasionally he uses the same device to give a crescendo effect to a compact volume, as in the heads and necks of the light bearer and the fugitive.

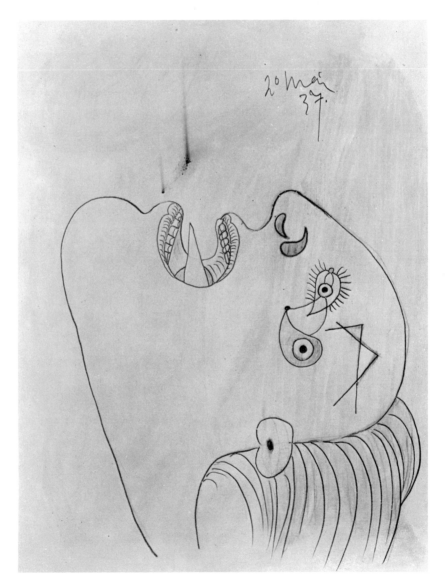

30 *Head of woman* Pencil and gray gouache on white paper.
 9¼″ x 11½″. Dated "May 20, 37."

31 and 32

Four days later the crying head is turned forward and thereby clearly removed from the figure of the mother in *Guernica*. We have here another partial theme of the mural developed toward complete independence. This had happened a few weeks earlier with the screaming head of the horse (sketch 9), and the subject of this new offshoot is of course essentially the same. The crying animal is now a crying woman—a change of vehicle which makes the theme more significant. Relieved from the context of the mural, the head can return to a more normal position. Off and on during 1937 Picasso works on this portrait of grief, in which one of the sentiments of *Guernica* is emancipated and cleared.

The streaming tears have been solidified into expressive objects. They supply the immobile head with the tracks of downward movement, appropriate to the subject. They also lacerate the skin with shocking grooves. Not the slight realistic pretext, but their ability to make the meaning of the subject more visible, justifies the presence of these devastating streamers.

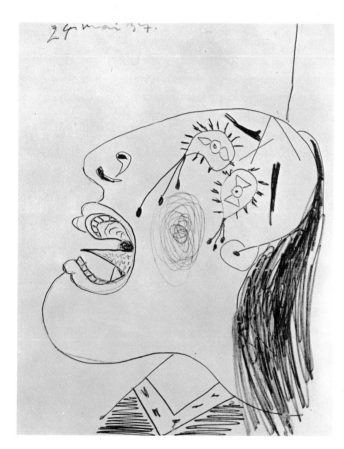

31 *Head of weeping woman* Pencil and gray
gouache on white paper. 9¼″ x 11½″.
Dated "May 24, 37."

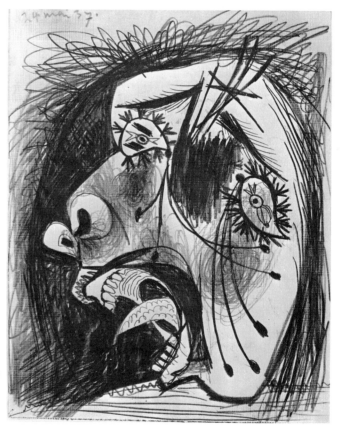

32 *Head of weeping woman* Pencil and gray
gouache on white paper. 9¼″ x 11½″.
Dated "May 24, 37."

33

The nature of another head remains to be determined: that of the dead warrior. At the early stages of the canvas the status of this element was still uncertain. The head lay face down. A definitive drawing will be done later (sketch 44). At present, the painter experiments with the character of the lines to be used for the profile. The first outline, visible under a wash of gray gouache, tells us that the painter started with a wavy, continuous curve not too different from the final one. For the moment, however, he has replaced it with definite, separate, straight-line strokes, perhaps in order to discern the spatial orientations more clearly. The profile is placed a little more obliquely than that of the first outline.

In an outline so ambiguously oriented as this one, the spatial position of the profile is determined not only by its own shape but also by the distribution of weight within the whole object. If one covers first the upper eye and then the lower, one observes that in the first instance the head lies more horizontally whereas in the second the main axis of the object runs obliquely and the head is raised. When the lower eye alone controls the pattern, the visual weight is concentrated at the bottom of the center of the head and tends to distribute itself from there symmetrically, forcing the ambiguous outline of the profile into the horizontal position. The upper eye concentrates the weight in the forehead and thereby produces an obliquely oriented main axis. The combination of the two eyes keeps the head suspended between the positions of lying dead and being raised—a kind of ambiguity that seems generally to appeal to Picasso because of the complexity of the attitude it implies and the tension it creates. The final solution of the problem in the mural will be discussed with regard to sketch 44.

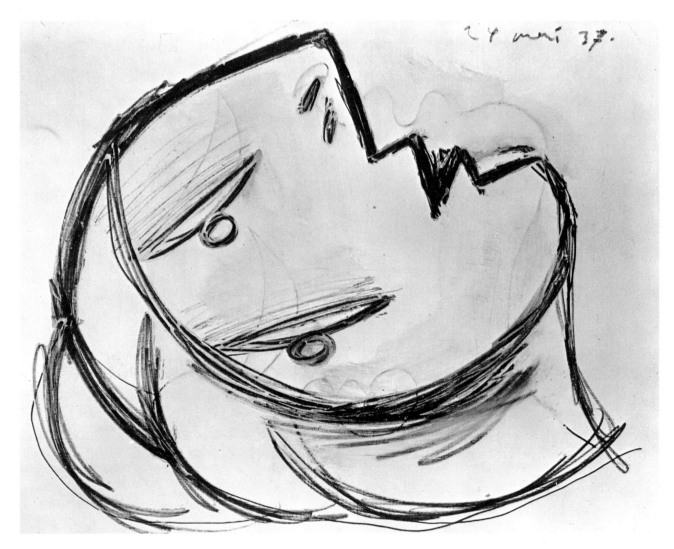

33 *Head of warrior* Pencil and gray gouache on white paper. 11½″ x 9¼″.
 Dated "May 24, 37."

34

The painter continues to be attracted by the independent subject of the grieving head. The modern artist's privilege of shaping an object as he pleases makes it possible for him to wrest from familiar things new interpretations and expressions. I mentioned earlier (sketch 25) Picasso's attempt to separate the function of the eyes from that of the mouth. To some extent this is done here by excluding the mouth from the sphere of the head, which is consequently monopolized by the eyes. The oblongs of the eyes run parallel to the outline of the head, and the circularity of the balloon of vision is opposed by the forward push of the mouth, which is secondarily reinforced by the nose in the head bubble itself. This separation of functions endows vision with the expression of centrifugal expansion, reminiscent of light rays spreading from a center in all directions, and leaves the mouth limited to, and concentrated on, the theme of linear attack.

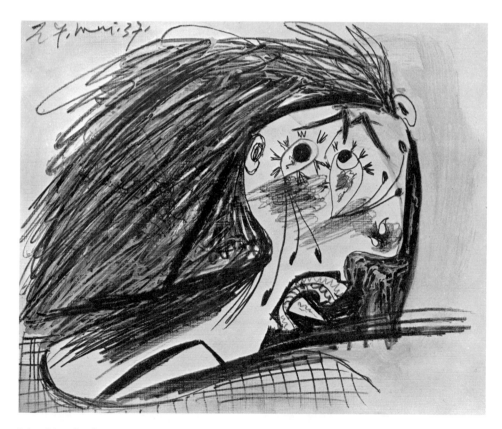

34 *Head of weeping woman* Pencil and gray gouache on
white paper. 11½″ x 9¼″. Dated "May 27, 37."

In the very first stage of the final canvas, outlined more than two weeks before this drawing was made, Picasso had settled for the figure of the falling woman to fill the right wing of the mural. Why would he now try out a man for the same spot? The only answer that suggests itself is that the bearded man occupying the corresponding place in the *Minotauromachy* may have emerged from memory momentarily.

The drawing is, however, interesting as a radical example of the novel and paradoxical symmetry obtained by turning the profile head fully ninety degrees upward. The chin and the top of the head are made to correspond to each other the way the two ears do normally. The static expression obtained by this striking symmetry is the same used in the mural for the head of the mother. In sketch 35, the central axis of the neck is reinforced within the head by the vertical eye, a strong supporter of the over-all symmetry. The other eye supplies the horizontal—that is, the position in which eyes are normally seen. Picasso often shows that he is aware of the estrangement that results when an object abandons its customary spatial orientation. Realistic painting has made us familiar with the curious appearance of faces turned upside down. The elementary sense of vision, however, keeps refusing to accept the intimation that objects preserve their identity regardless of their orientation in space. Modern art, reminding us of the importance of what is immediately given to the

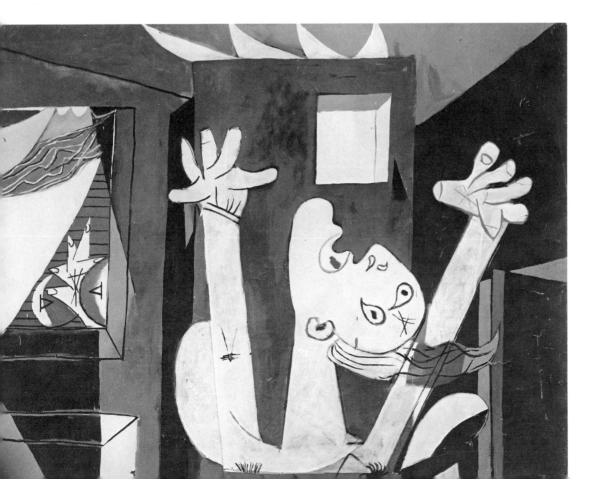

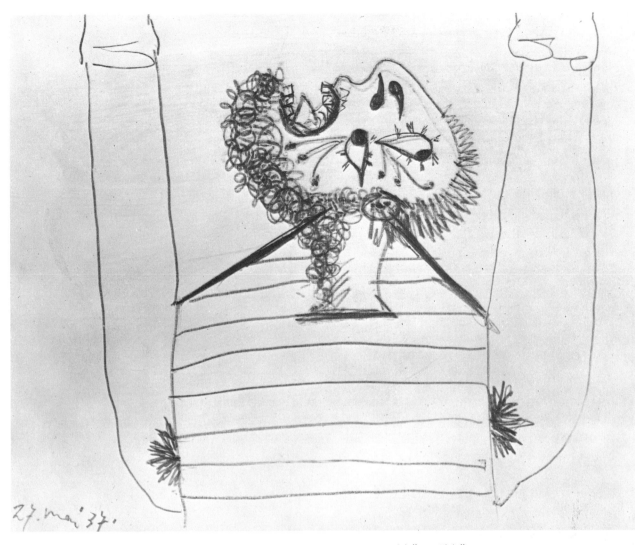

35 *Falling man* Pencil and gray gouache on white paper. 11½″ x 9¼″.
 Dated "May 27, 37."

eyes, often supplies normal shape and normal position together with the deviation.
In the present drawing, the eye at the right recalls the normal horizontal level and
thereby weirdly reinforces the paradoxical notion that the head, although turned
upward, is really in normal position. We are tempted to see a fantastic creature, which
carries the hole of its mouth as well as its nose on top of its head. Hence the static
character of this attitude, which I have discussed in relation to sketch 30.

93

36

Finality, I suggested earlier, is a state disliked and perhaps feared by Picasso. Variations on a theme already established in the mural let the artist's imagination keep on inventing new shapes for a subject that, like all subjects, is inexhaustible, and assure him that his creation continues to live beyond its burial on the canvas. Is it too daring to assume that for an artist of highly dynamic temperament the immobility of the accomplished work may be associated not only with immortality, as has often been asserted, but also with death? After all, in *Guernica* death is represented by a statue—that is, a work of art.

This particular sketch may fulfill an additional purpose. It presents a theme which, in the form finally adopted, had not been studied in isolation. Free from its context, the group can reveal the visual forces which are inherent in it and impinge upon the surrounding areas. This observation is suggested in particular by the two wing-shaped forms, perhaps representing clothing. Colored with a purple crayon, they emphasize and continue the two diagonal axes around which the group of mother and child is built. The dominant diagonal is based on the dead head of the child, and carries the consequence of this death visually through the stretching and bending of the mother's chest, neck, and head. In the mural, this axis is straightened to a degree of almost becoming a vertical. In the sketch, in which the reference to the bull is missing, the whole group is more compact and self-contained. The secondary diagonal gives order to an assembly of parts of the body: hands, feet, arms, and breasts. Because of its pointed shape, the female breast is often endowed with directed intention by visual thinking. In the sketch, one of the breasts reaches for the child, who cannot respond; the other turns inward as in despair. In the mural, the two breasts are aligned in such a way as to relate also to the testicles of the bull, thus involving the paternal element. It may be observed in passing that the pictorial problem of how to remove the hindquarters of the left-oriented bull from the center of the mural was finally solved in a way that accomplished the task not only negatively but also provided a meaningful function for the generative aspect of the bull. Set against the foil of the bull's body, mother and child are part of a family group.

A large blue patch in the lower center of the sketch serves as a visual pivot for the two wing-shaped protuberances. How closely these wings are integrated with the figures themselves may be gathered from a detail: the contour line of the upper breast does not lead organically into the neck but continues as the contour of the large wing, and the neck in turn is united by the artist's pencil with the smaller wing to the left.

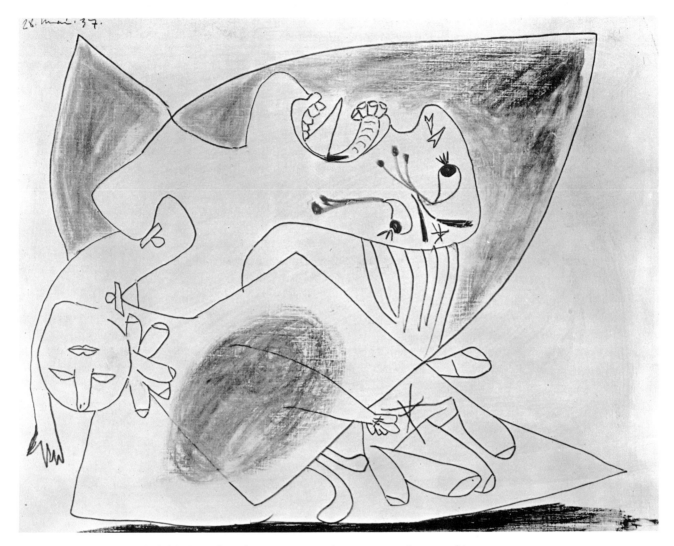

36 *Mother with dead child* Pencil, color crayon, and gray gouache on white
 paper. 11½" x 9¼". Dated "May 28, 37."

37

Another version of the theme was done on the same day—we do not know whether earlier or later. Not larger than sketch 36 but more elaborate in subject matter and coloring, this presentation of mother and child is certainly more remote from that in the mural and a more independent and complete composition. One might describe it as a synthesis of the feminine element in *Guernica*. It combines the subject matter of mother and child with the attitude of the fugitive. The bent frontal leg and the stretched back leg mirror the running step of that figure. At the same time, the raised arm and the burning house with the window are taken from the section of the falling woman. Further, the child is pierced by the centrally located vertical arrow, and this replacement of the horse by the child suggests that the open mouth of the child, not to be found in other representations of the child, reflects that of the horse. This example demonstrates the extent to which the attitudes of *Guernica* are independent of what I called the characters. New combinations of attitudes and characters are still feasible even though their relationships in the mural are settled by now.

Of the two purple wings in sketch 36, the larger one is present here also, and the central blue patch is on the thigh of the mother, where its compositional usefulness is less evident. It looks like a leftover, and thereby helps to confirm the impression that sketch 37 was indeed done after sketch 36. (The large circular spot on the right is black in the original.)

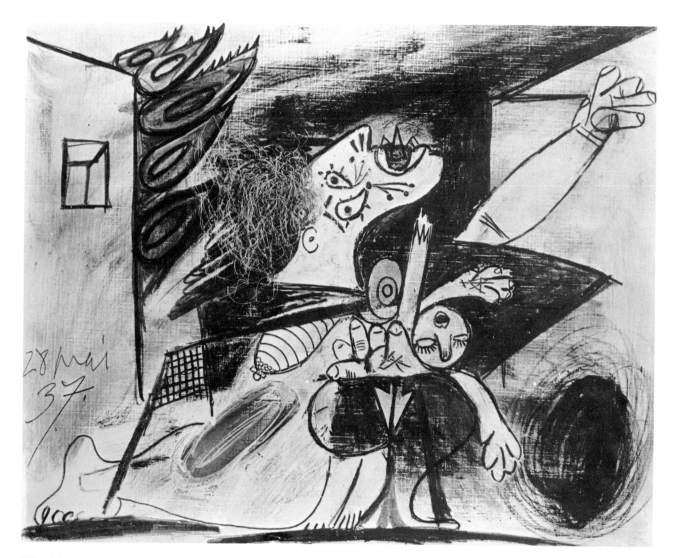

37 *Mother with dead child* Pencil, color crayon, gray gouache, and hair on
 white paper. 11½″ x 9¼″. Dated "May 28, 37."

38, 39, 40

The house with the window, a mere hint at the *Guernica* theme, is combined in sketch 38 with the head of the weeping woman. The painter is working in the mood of *Guernica* but on a composition separate from that of the mural. The head is not a detail, taken from a larger whole, but a complete and closed entity in itself. This can be seen clearly in a similar drawing, done three days later (sketch 39), in which the head, deprived of its neck, rests on a base of clothing like a ball-shaped *objet d'art* placed on a pillow. The rows of fingers and of teeth, which originally connected the head with the surrounding space, have disappeared under the transparent wash of gouache, with which Picasso covers the first draft in many of these sketches. The naked, polished ball remains. Another three days (sketch 40) and the head is still further separated from the base on which it rests. The architectural background has disappeared, and we are left with a highly ornamental configuration of shapes, apparently far removed from the experience of human suffering, which gave rise to it originally.

I said earlier that the streaming tears are not simply realistic symptoms of grief. In the colored drawings they are drawn in red, an integral part of the total color pattern that characterizes the head. There is nothing momentary about them, nor are they subject to the gravitational limitations of flowing liquids. They are so much a part of the head itself that in such sketches as 34, 36, or 37 they flow upward, rather than downward, to accompany the tilt of the head or eye. This can be done only at a reality level at which spatial relationships are not generally bound to those of the model. Just as the eyes move freely within the pictorial area of the face, determined only by the expression they are to convey, so the tracks of the tears are free to assume the shapes, sizes, and places that make them fulfill their purpose in the picture.

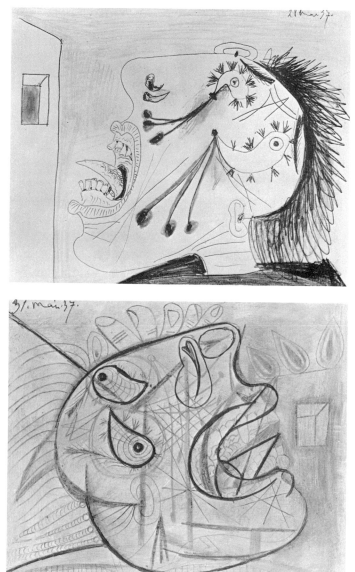

38 *Head of weeping woman* Pencil, color crayon, and gray gouache on white paper. 11½″ x 9¼″. Dated "May 28, 37."

39 *Head of weeping woman* Pencil, color crayon, and gray gouache on white paper. 11½″ x 9¼″. Dated "May 31, 37."

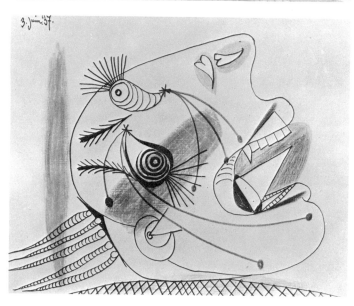

40 *Head of weeping woman* Pencil, color crayon, and gray gouache on white paper. 11½″ x 9¼″. Dated "June 3, 37."

41 and 42

Two more drawings on the same subject, both colored in strong and pure hues were done that day. Sketch 42, perhaps done last, looks like a diagram of conflicts constructed by means of a variety of free-floating internal shapes. There are no verticals or horizontals, and straight lines are rare. In all pairs—eyes, eyebrows, nostrils—parallelism is avoided. The twins disagree with each other's direction and poke into each other. The tracks of the tears get entangled with one another and with other shapes. The hairs, closest to some sort of group discipline, are nevertheless arranged in such a way as to avoid an obvious order of placement, shape, or orientation. In comparison, sketch 41 looks highly organized. Thus, sketch 42 comes close to an abstract representation of conflict, upset, disorder, done with purely visual means at the expense of a gradually disintegrating natural object.

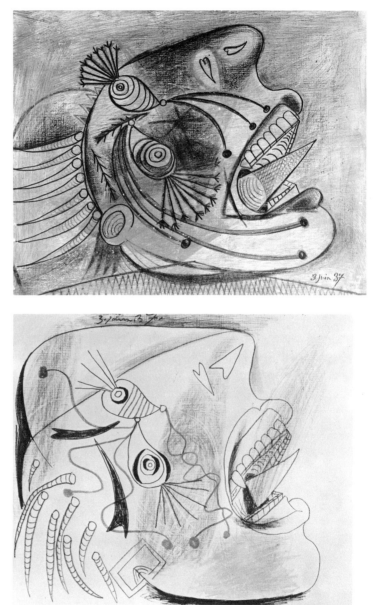

41 *Head of weeping woman* Pencil, color
 crayon, and gray gouache on white
 paper. 11½″ x 9¼″. Dated "June 3,
 37."

42 *Head of weeping woman* Pencil, color
 crayon, and gray gouache on white
 paper. 11½″ x 9¼″. Dated "June 3,
 37."

43

Three more drawings, done on June 3 and 4, are the last to be directly related to the mural. If we were permitted to assume that Picasso worked on the mural as long as he made sketches for it and no longer, we would have to conclude that *Guernica* was finished in those early days of June. Whether this is true, or whether the work occupied the painter for another few weeks, is of little importance for our present purpose.

The head of the warrior was one of the last elements to be determined. In examining the preparatory stages of the mural itself, we shall see that at first, turned upward, it was placed near the base of the central vertical axis. Later it moved to its final position in the left wing, but was placed upside down. It is that phase of the invention which we find reflected in sketch 43. By being moved toward the left, the head encounters the horse's hindleg, and this encounter must have contributed to anchoring it at its final location. For, as I suggested in commenting on sketches 17 and 18, the combination is not meaningless. In the pictorial concept of the bent-down horse, the meeting of head and hoof indicated that the collapse had gone full circle. The top had reached the bottom. The contrast between the head—which is the seat of the mind—and the lowly, earth-beating hoof is enhanced when the head of the horse becomes the head of a man.

This particular head is, however, less and more than human. Less, in that, turned from flesh and blood into stone, it neither notices nor feels the contact with the hoof and the meaning this contact entails. More, in that the warrior does not represent merely the individual fighting man but a military monument of an historical event. As a fact of history, the collapse, although not sensed as an individual experience, has a great impact of its own.

The encounter of head and hoof is made visible as a crossing of horizontal and vertical. In the larger sense, this is a reflection of the decisive compositional crossing of the central upright column, crowned in the mural by the lamp of the light-bearing woman and the head of the horse, as against the horizontal base of death, upon which the scene is acted out as though on a carpet.

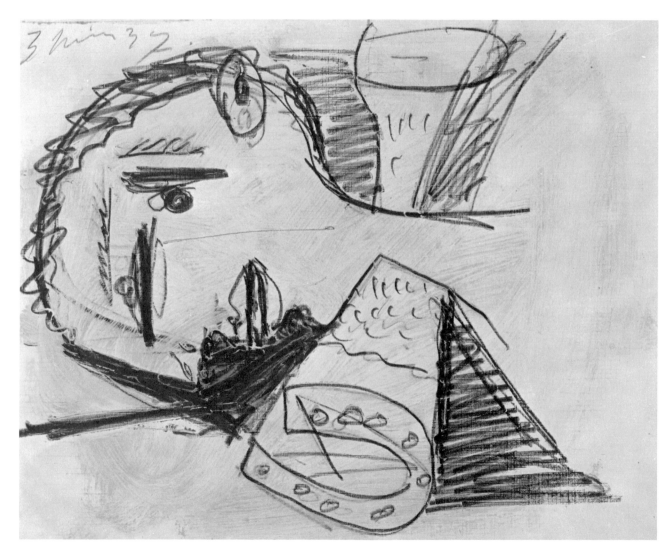

43 *Head of warrior and horse's hoof* Pencil and gray gouache on white paper.
 11½″ x 9¼″. Dated "June 3, 37."

44

With his head facing the ground, the warrior would be truly dead. Turned away from the scene, he would no longer participate in it, except as a body to be walked on or to be reacted to. In one of his major last moves, Picasso turns the dead man's face upward. Correspondingly, the mouth, which was closed in sketch 43, now speaks or calls. It is the silent appeal of the statue, the appeal of death—but, in visual language, an appeal nevertheless.

Further, the head is now truly transformed into that of a stone figure. It has lost all appendages, its hair and eyebrows, its ear and lips. There remains a polished solid, rather like the weeping heads Picasso had drawn during the preceding days. It also is related to the head of the falling man (sketch 35) with his profile turned into the horizontal and a vertical eye establishing a symmetry axis in the center.

The estrangement of the figure is further enhanced by a change of the facial contour. Turn sketch 43 by ninety degrees, and you see a likeness of a human profile; do the same with sketch 44, and you are struck by the inhuman character of the face. The nose, the upper lip, and the chin have been made to fit something like a geometrically regular sine curve. The three amplitudes are almost equal in the size, shape, and location of the curves. So are the two negative spaces formed by the mouth and the cavity between nose and lip. The regularity, over-all flatness, and symmetry of this profile remove it from human spontaneity and endow it with the rigidity found, less radically, in the face of the mother (cf. the comment on sketch 30). This newly attained resemblance of the two faces staring upward at the bull enhances the compositional unity of the mural's left wing.

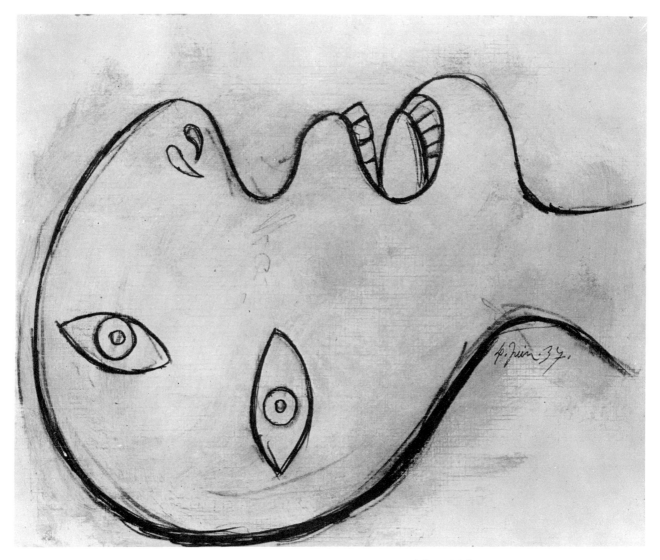

44 *Head of warrior* Pencil and gray gouache on white paper. 11½″ x 9¼″.
 Dated "June 4, 37."

45

This final sketch for a detail of *Guernica* establishes the important starting point in the lower left corner of the mural. The hand of the warrior also marks the corner at the base of the central compositional triangle. In the drawing we see a right hand, enlivened by the tensions arising from the irregular spacing of the fingers, the bending of the thumb, the muscular squeezing within the palm. The hand in the mural is probably also a right hand, attached to the left arm, but this paradox is hardly apparent since the hand now approaches the shape of a regular star pattern. It approaches geometry, just as the profile curve or the shape of the eyes do in the head of the warrior, to whom the hand belongs. In the mural, the fingers will be spaced more regularly, the palm will be more nearly a simple polygon, and the internal lines will cease to be realistic grooves and instead suggest the shape of an ornament. Stable and solid, this starlike pattern will be appropriate for the character of the mural's left wing, the wing of the bull, just as its opposite number, the twisted foot, will fit the right wing, that of the falling woman. In the upper corners of the mural, by the way, there will be another variation of a theme: the concentrated but intensely dynamic torch of the bull's tail on the left will correspond to the linings of spreading but mechanically shaped flames on the right.

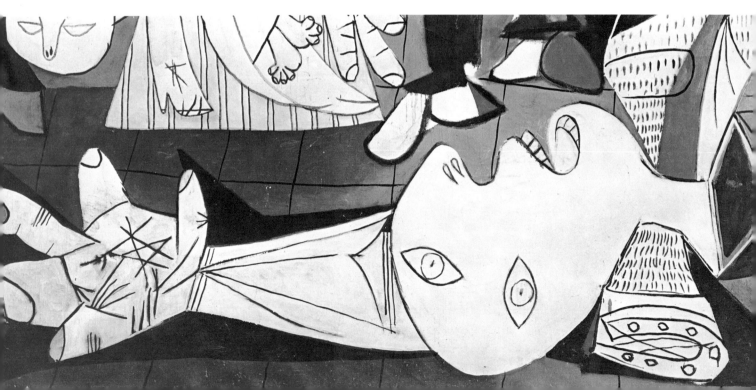

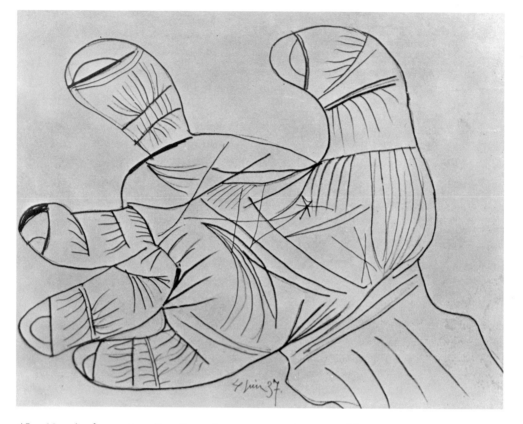

45 *Hand of warrior* Pencil and gray gouache on white paper.
 11½″ x 9¼″. Dated "June 4, 37."

46-61

The remaining drawings and paintings go beyond *Guernica*, and therefore beyond our purpose. They are reproduced here in order to make a fairly complete pictorial record available. The studies of the weeping woman gravitate toward a separate artistic task, which leads to a representative oil painting, done in October (sketch 60). The theme of mother and child is kept alive in sketches 51 and 57, done on June 22 and September 26 respectively. (Reference should also be made to three variations on the same theme of mother and child added by Picasso to the second plate of the etching *Dream and Lie of Franco*, together with a sketch of a weeping woman. These four miniatures, not reproduced in this book, fill the space left empty on the copper plate after Picasso had worked on it in January, 1937. The additions are dated June 7.)

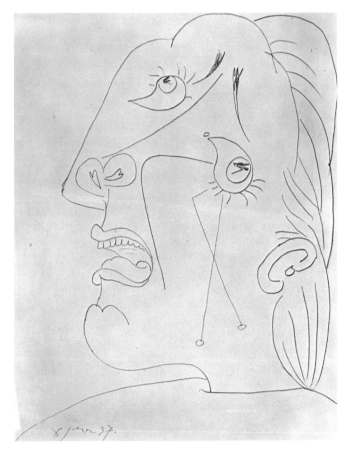

46 *Head of weeping woman* Pencil and gray gouache on white paper. 9¼″ x 11½″. Dated "June 8, 37."

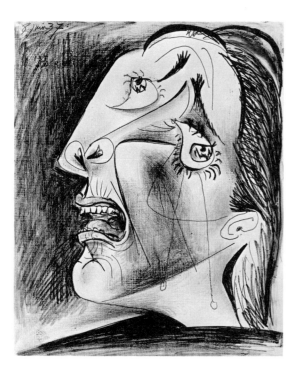

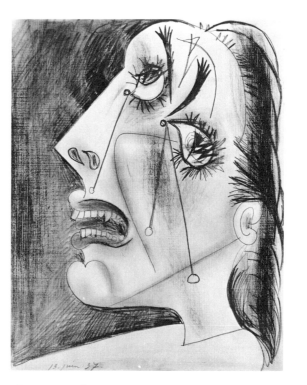

48 *Head of weeping woman* Pencil,
 color crayon, and gray
 gouache. 9¼" x 11½".
 Dated "June 13, 37."

47 *Head of weeping woman* Pencil, col-
 or crayon, and gray gouache.
 9¼" x 11½". Dated "June 8, 37."

49 *Head of weeping woman* Pencil and
 gouache in color on cardboard. 3½" x
 4⅝". Not dated. June 15?

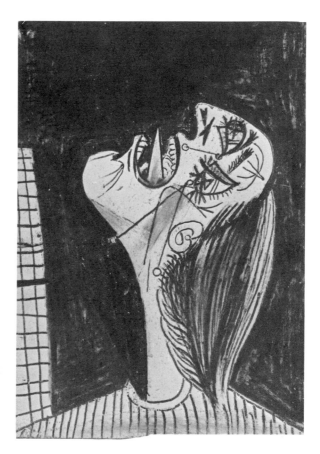

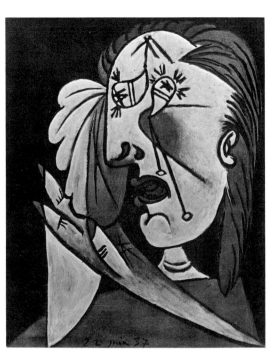

50 *Head of weeping woman with handkerchief*
Oil on canvas. 18⅛″ x 21⅝″. Dated
"June 22, 37."

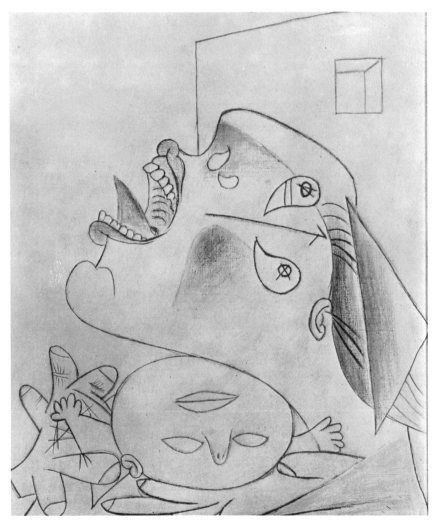

51 *Mother with dead child* Pencil, color crayon, and oil
on canvas. 18⅛″ x 21⅝″. Dated "June 22, 37."

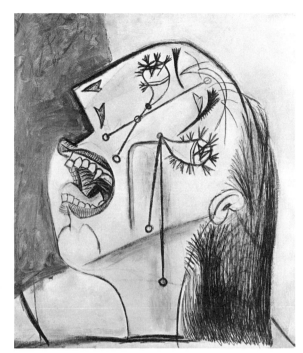

52 *Head of weeping woman* Pencil,
 color crayon, and oil on canvas.
 18½″ x 21⅝″. Dated "June 26,
 37."

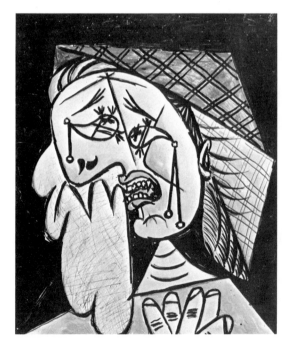

53 *Head of weeping woman with hand-*
 kerchief Oil on canvas. 18⅛″ x
 21⅝″.

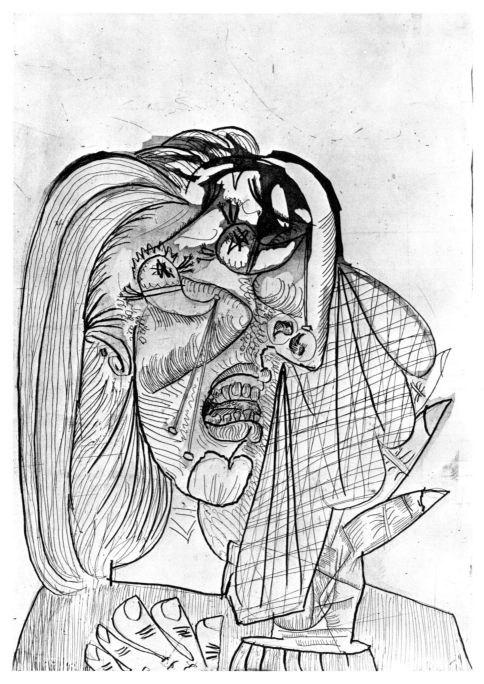

54 *Head of woman with handkerchief* Etching with aquatint. First
state, no. 6/15. 19½″ x 27¼″. Signed "Picasso." July 2?

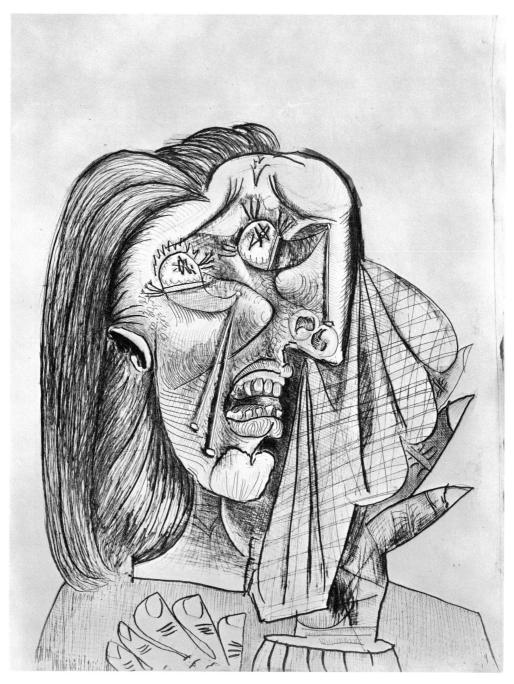

55 *Head of weeping woman with handkerchief* Etching with aqua-
 tint. Second state, no. 4/15. 19½" x 27¼". Signed "Picasso."
 July 2?

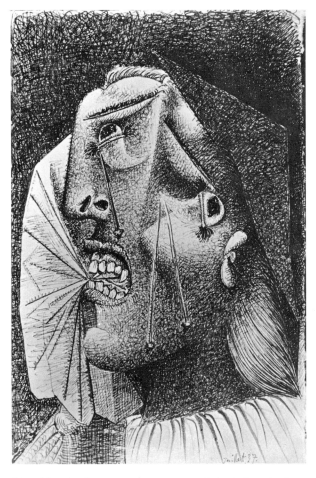

56 *Head of weeping woman with handkerchief*
 Pen and ink on white paper. 6¾" x 10".
 Dated "July 37." July 4?

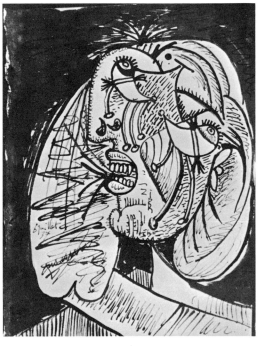

57 *Head of weeping woman with hand-
 kerchief* Pen and ink on tan
 paper. 4½" x 6". Dated "July 6,
 37."

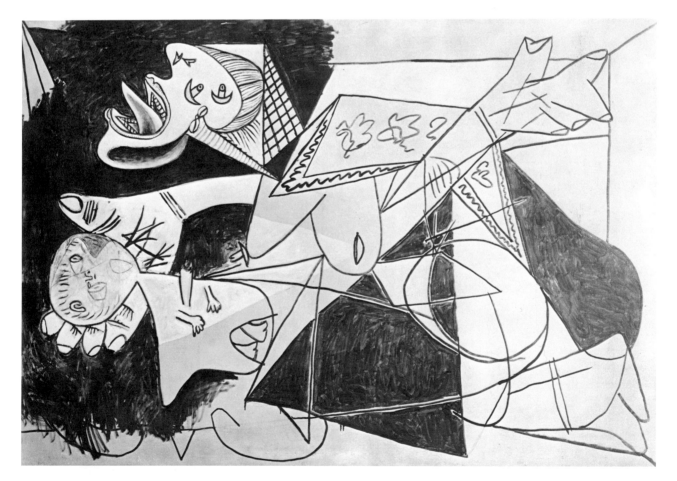

58 *Mother with dead child* Monochrome oil on canvas. 76¾″ x 51¼″.
Not dated. September 26?

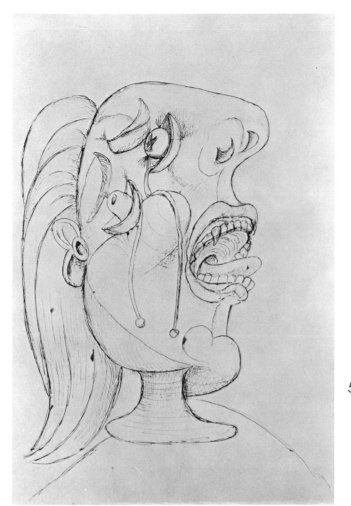

59 *Head of weeping woman* Ink and pencil on white paper. 23″ x 35⅜″. Dated "October 12, 37."

116

60 *Head of weeping woman with handkerchief* Pen and ink with monochrome oil on canvas. 18⅛″ x 21⅝″. Not dated. October 13?

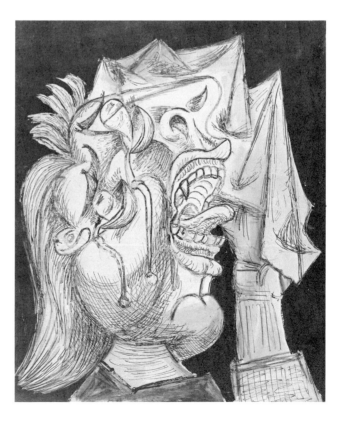

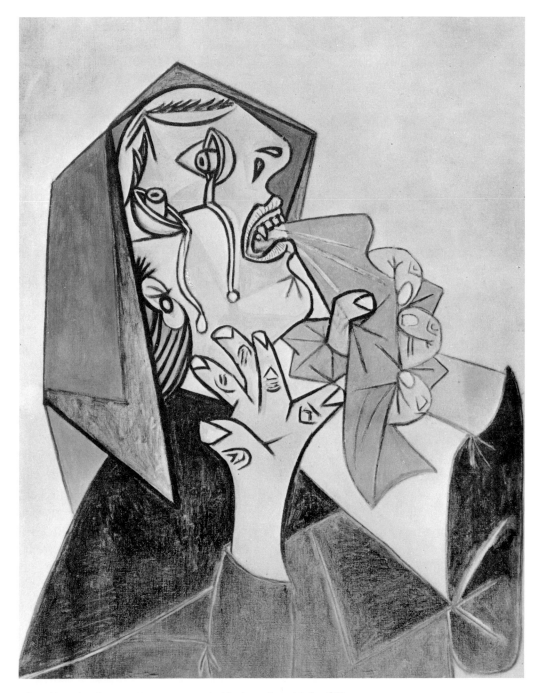

61 *Head of weeping woman with handkerchief* Oil on canvas.
28⅝″ x 36¼″. Not dated. October 17?

THE STATES OF THE MURAL

FIRST STATE

The earliest photograph available of Picasso's work on the final canvas is dated May 11. This takes us a few weeks back to the time when the sketches around number 20 were done. Seven photographs of the work in progress are at our disposal, but the later stages are not dated. Nor do we know, as I mentioned before, exactly when the work was completed.

The technically imperfect long-shot photographs do not allow us to judge details with certainty; but a great many relevant facts can be gleaned from the over-all composition. The bull was first drawn in front face, then turned away. His body still reaches into the central area of the mural, with the light bearer's lamp illuminating his back. Mother and child are outlined in their final shape; but since the bull's body does not yet serve them as a foil, they are only adjacent to him, exposed and forlorn, rather than united with him in a closed group. The final position of the bull will have the further advantage of turning him toward the central group with only his head averted, and correspondingly horse and warrior will be turned toward him. At the present stage of the picture, the central theme of the carnage takes place without reference to the bull; the bull, in turn, snubs the event. His detachment is not yet counterbalanced by the necessary connection of the themes.

The warrior, with his head near the center of the composition, is locked in close dialogue with the wounded horse. The turned-down neck of the horse helps to frame the theme of suffering. However, a vigorous attempt to break this confinement is made by means of the muscular, erect arm of the man. It opposes the theme of death, and its fist creates a powerful center at the spot to be occupied later by the sun lamp. The motif of the arm is new as subject matter, but the idea of an upward-reaching shape in the center of the composition was with Picasso from the beginning. In the very first, quick sketch (number 1), the hindlegs of the dead horse played the part here assumed by the arm of the dead man. On the same day (sketch 2) there appears the insistent theme of the horse with the upward-reaching neck, which in sketch 6 is placed in the center of the picture. As the horse bends downward it ceases temporarily to fulfill this function, now taken over by the soldier's arm. But in the end the horse will rise again.

There are several disadvantages to this attempted solution. The stable upright of the arm duplicates the function of the bull as well as that of the central column topped by the lamp of the light-bearing woman and indicated in the drawing by a vertical line. This multiplication weakens the two other "towers of strength" and, at the same time, centers the composition in an object of inferior rank: the fist can hardly compete in significance with the head of the bull or even with the lamp; it is mere force, a clump of muscles and bones, unable to see or speak or to emit light.

In the right wing of the composition there is still considerable uncertainty. The warrior is duplicated by a dead female figure with outstretched arms. Her position

118

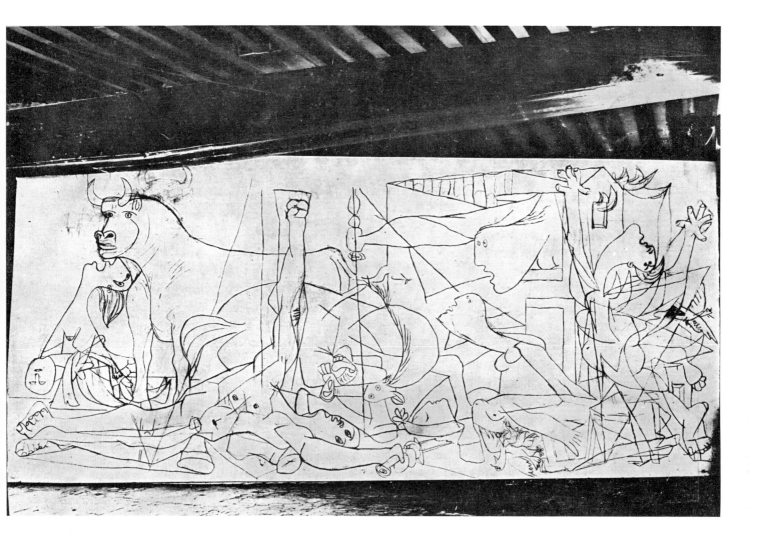

anticipates the final one of the warrior himself, including even the confrontation of head and hoof. Nothing will remain of her but the fingers of her hand, transformed into a flower—one of the visual puns in which Picasso indulges during the growth of his works when the subject matter is only loosely related to the formal patterns he is elaborating. (A parallel in the artist's sculpture can be found in his use of *objets trouvés*—that is, the transformation of discarded junk into new subject matter. Images remaining from earlier stages of invention are, in a sense, *objets trouvés*.)

The dead woman is accompanied by a dead bird, indicating, according to what we know from our discussion of sketches 2 and 6, that even her soul is murdered. This thought contradicts the final spirit of the picture, and will not last. Nor will the second bird, emerging from the burning woman at the extreme right. The dead woman occupies the space needed for the legs of the fugitive, who is further interfered with by the falling woman. The large falling woman fills the entire right wing of the canvas. Her left foot, all but unchanged, will become that of the fugitive; her left hand and arm, interfering with the roof and weakening the vertical base of the lightbearing woman, will be pulled back; and the window, moved to the right, will be more strikingly coördinated with the head.

SECOND STATE

The view of the mural in this photograph is confused by the rafters of the studio at the top, the black shapes of the railing-like object at the left, the table with its cast shadow, and the circular shade and stand of the floodlight at the right. These extraneous objects must be distinguished from the black areas, applied by the painter to indicate the ground and also to clear for free action certain problematic parts of the composition.

Foremost among these problem areas is the center, where the soldier's arm cuts across a crucial region: the wounded body of the horse, the center of the attack. To eliminate this crossing, the fist is now severed from the soldier's body. However, its weight is increased, both visually and in subject matter. Enlarged and more articulate, the fist goes beyond a mere threat by clasping a bunch of flowers and surrounding itself with a flaming halo. The brightness of this new celestial apparition eclipses the small lamp and thereby fatally weakens the contribution of the light-bearing woman. It is also too powerful to be contained within the space available above the bull's back. Moreover, it makes a positive symbol monopolize the direction from which the enemy must have struck, thus shielding the horse from an attack which nevertheless took place.

The dead bird has been transformed into a sprawling hand; the fugitive woman has acquired her left hand and powerful knee, and laid claim to the foot in the right corner.

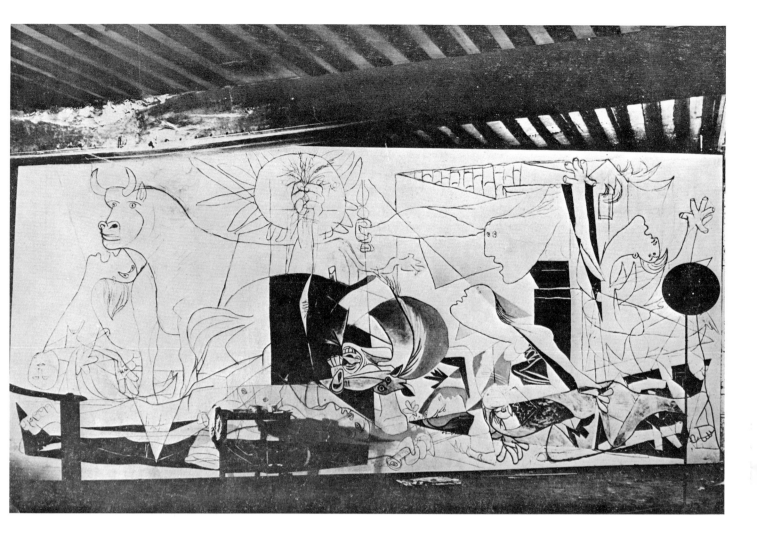

THIRD STATE

Substantial changes have occurred in the central group. The warrior is turned around. The removal of his head greatly helps to relieve the crowding in that area. Now close to the bull and the mother, the head of the warrior establishes the first strong connection between the central triangle and the left wing of the mural. However, at this stage it does so only by its new location, not yet by its attitude. Why has the face been turned downward? Perhaps it seemed awkward to have the bull stand on a man's profile. Perhaps also the notion of a necessary communication with the bull was just beginning to dawn on the painter, and the conceptually simpler separation of the groups from each other still prevailed.

The horse, on the contrary, is relieved from the upside-down position of its head. It begins to rise and to direct its attention toward the left. The upright arm of the warrior has been demolished, and the halo, now devoid of fist and flowers, is reduced to a size better suited to the available space and the compositional weight of the object. A black strip across the bull's back announces that the area is condemned. And on the right, the powerful step of the fugitive greatly enhances the impulse of the central group toward the left. The falling woman, forced out of the way, has profited from the eviction: the tilting and shortening of her body, which in the final composition is further played down by darkness, concentrate the expression of the figure around the screaming head and the raised arms.

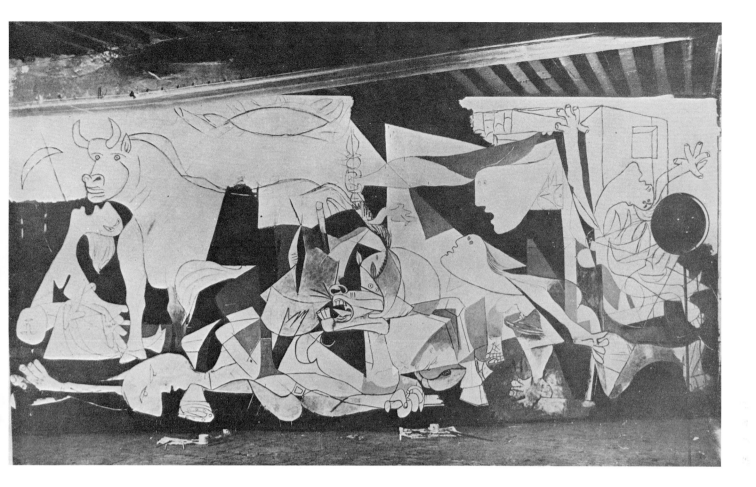

Any vacancy is an invitation to invention. The empty space at the extreme left was filled with a crescent in the third state. Little meaning seemed to be attached to this new celestial body; it looked as though it simply answered the demand that something ought to be there. Did the need for a filler suggest the turning around of the bull? This need may well have been what the logicians call the proximate cause, which, however, could hardly have brought about the action, had it not solved the problem of the bull's position. The gain is remarkable. With one strategic move, the painter refines the attitude of the animal: the bull now faces the scene, yet his head is turned away; the empty space at the left is filled with the eloquent tail; mother and child are enveloped and bolstered by the protective torso; the animal's hindquarters are removed from the center. Truly an ingenious invention.

The shifting of the bull's body has, in turn, created a vacuum. Again, as did the crescent, a neutral object occupies the space. Again, we may ask whether this emptiness invited the invention of the bird, which will finally fill it, and further, whether the newly cleared breathing space made the horse raise its head. And again, the answer must be that in the creative process material openings or obstacles constantly interact with the demands of meaning, and that the work gains from proceeding at these different levels of the problem situation simultaneously. Meaning required that the horse raise its head, so that the call of suffering would occur at the same proud level at which the bull holds his imperturbable, watchful head and so that the appeal would be addressed and transmitted to that remote yet spatially near monument of survival. But the horse could not raise its head unless there was space in which to put it.

The organization of space in itself can never be the final purpose of an artist, because space is only a means to an end. But to ignore formal problems and opportunities or to dismiss them as inferior is to forget that the artist thinks in shapes.

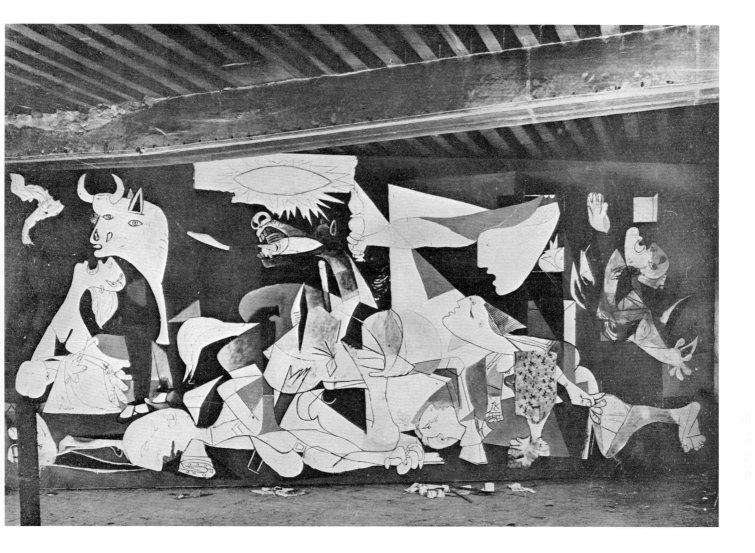

FIFTH STATE

Now that the warrior's head has come to lie at the left and his neck to cross the horse's foot, the second dead figure on the ground has become redundant and is therefore removed. However, it does leave behind in Picasso's mind the upward orientation of the face and the cutting off of the neck in the manner of a piece of sculpture. In the fifth state, the warrior's neck shows a break and the corpse has neither body nor legs, but the transformation into the statue has not yet occurred.

The disappearance of the second head has made some space, which is being filled by a turn of the hand with the sword. This diagonal recession into the third dimension relieves the flat arrangement of verticals and horizontals prevailing along the lower border. The pattern of the falling woman has been streamlined. The new geometry of the flames adapts their earlier realistic confusion to the more formal style of the picture, and the rigid compactness of the skirt puts the dead weight of the falling body in opposition to the animate expression of head and arms.

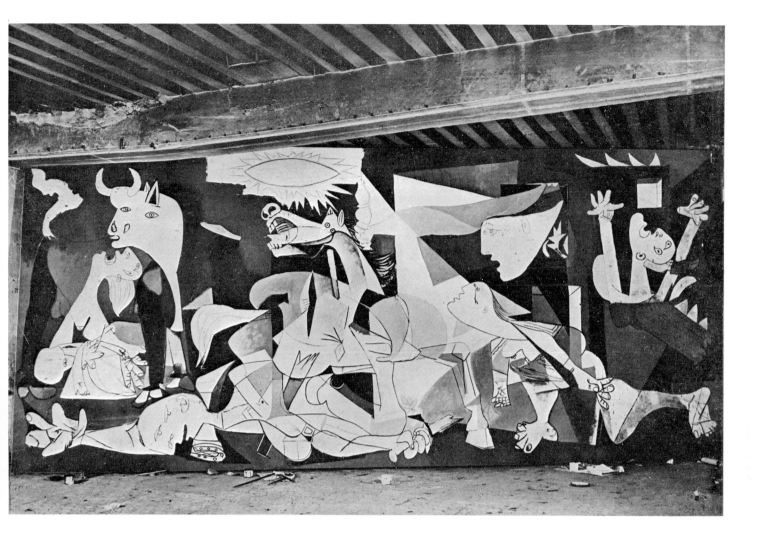

SIXTH AND SEVENTH STATES

After the minor adjustments of the sixth state, the seventh carries the work nearly to its completion. The turning around of the warrior's head is the concluding compositional move. It connects the base of the central triangle—that is, the scene of devastation—directly with the bull, and establishes the parallel between the dead man's head and the mother's head, thereby producing a further connection between the two groups.

The turning around of the head is directly related to the spelling out of three-dimensional space in the left wing of the mural. Without the receding floor, the bull would stand on the warrior's profile and thereby squash the appeal of the face. The floor places him behind the head. The depth dimension is further clarified by the table, hardly an impressive solution, although the surface supplies a base for the bird and the edge reinforces the boundary of the compositional triangle. The rays of the ceiling sun lose their excessive flamboyance by being supplied with cast shadows, and the confusion at bottom center is attacked with the radical remedy of even further dismembering the warrior. Again, one might be tempted to credit purely spatial needs for this solution. The hindlegs of the horse in their relationship to the right arm of the warrior and the arrows are clarified as much as they will ever be, and the bent foreleg delineates itself more clearly. The stippled texture of the horse's hide helps to distinguish the intricate body of the animal from its surroundings. But again, mere visual order would be too superficial an accomplishment. If it is true that the need to get the body of the dead man out of the way suggested his transformation into a fragmentary statue, we are confronted with a final example of the intimate bond uniting the practical strategy of pictorial shapes and the profound meaning made visible by it.

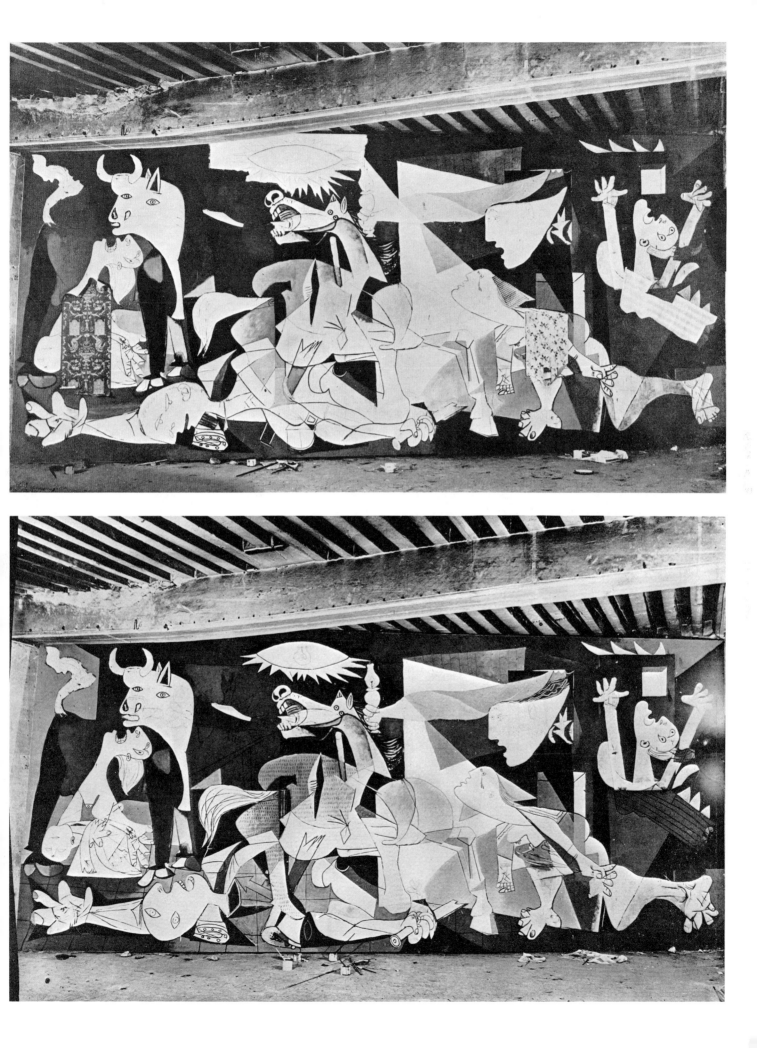

IV CONCLUSIONS

To read descriptions of pictures is at best strenuous; but whoever has followed the foregoing analyses of sketches and stages can hardly fail to have shared the excitement of a treasure hunt leading along the path to the creation of a most significant painting of our century. In the process the reader is likely to have made certain generalizations on the mechanisms of invention and transformation apparent in the examples. I shall not attempt here to make them all explicit. Some of the observations I have noted earlier are too tentative and isolated to justify the promotion from hunch to hypothesis, not to mention the tedious repetitions such a summary would require. I shall therefore limit myself to outlining several of the over-all trends which reveal themselves to a backward glance at the total material.

The most commonly observed development in a process of growth is that from simple beginnings to a complex end. Do we find it in the growth of *Guernica* from the first sketch to the finished painting? We do not, if we are looking for a steady increase of complexity from stage to stage. In attempting to measure each sketch on some sort of scale of complexity, one would notice sudden reversals, such as the return to the almost childlike drawing of a horse in sketch 4. What is more, in most instances one would be unable to make the comparison at all, because it would mean comparing incommensurable objects. Picasso did not start from a small element of the work and continue to add piece after piece as though to a coral reef. Such a procedure, if it were applied by an artist, could hardly reflect the psychological growth of the concept, since only the most primitive kind of over-all organization could result from inventing detail after detail. Of course, a preëstablished pattern, such as the blueprint of an architect, can be given material shape by a builder in this piecemeal manner; but when it comes to the creation of an organic whole, neither nature nor man can work like a bricklayer.

Nature proceeds by the principle of gradual differentiation. Starting with a single cell, it has every element continue to grow in the context of the total development so that, strictly speaking, nothing is finished until everything is finished, and at any time everything is advanced approximately to the same extent. Nature grows,

whereas the bricklayer executes. The work of art is grown and executed at the same time. It depends upon the organizing power of one brain and the capacities of its tools: the eyes and hands; and, like all man's mature works, it is complex far beyond what the mind can conceive or the eyes and hands can make in one operation. Mind and eyes perform this feat by varying the range and the differentiation level of the task: when the range is large, the differentiation level is kept low, and vice versa. That is, at some times the total area of the problem is surveyed, but only with regard to the relationships of fairly large units; at others, a more limited area is worked out in greater detail. In this way, the complexity level of the performance remains fairly constant, just as, for example, a traveler looking at the world from an airplane loses in detail what he gains in range. The total result, obtained through successive operations, presents itself as a marvel of organized complexity.

Such a procedure, however, involves a risk for the necessary unity of the work, because during each act of execution the artist's concept is likely to grow essentially within the limits of the range in which he is operating at the time. The part of the picture on which he happens to work will tend to be treated as a totality and to grow according to its own separate nature. Similarly, work on the gross structure of the over-all pattern may fail to take into account the needs of the refinements. Therefore the artist is constantly faced with the problem of how to develop the part in terms of the whole. Picasso's sketches suggest that this can be done only in approximation. When, in numbers 19 and 22, he attempted to define the character of the bull, he arrived at a style of classical beauty unlikely to have been conceived for the mural as a whole. The bull whom he was trying to make visible was the bull of *Guernica*, but the bull alone. Consequently, the result he obtained overshot the mark and had to be corrected according to the demands of the total concept. In general, each sketch was found to exhibit a completeness which proved that the artist was not working simply on a detail but rather on a self-contained entity. The heads of the horse, in sketches 28 and 29, had the simplicity of an object not yet modified by the effects of its environment and by its reactions to those effects. Sometimes a detail, such as the hand with the sword in sketch 24, seemed to concentrate in itself more of the meaning of the total work and a more intense expression of that meaning than it could be permitted to carry within the context of the whole. The extreme example was that of the crying head, which absorbed the theme of suffering so thoroughly that it had to be given autonomous existence in paintings of the horse's head and later the head of the weeping woman.

The combination of growth and execution in the creative process leads, then, to a procedure which cannot be described as the successive elaboration of fragments or sections but which works out partial entities, acting upon each other dialectically. An interplay of interferences, modifications, restrictions, and compensations leads gradually to the unity and complexity of the total composition. Therefore the work of art cannot unfold straightforwardly from its seed, like an organism, but must grow

in what looks like erratic leaps, forward and backward, from the whole to the part and vice versa.

This process does not generally survive in the few preparatory versions remaining of works of art. One would have to watch the artist as though in a motion picture in order to notice the succession of manipulations reflecting the dialectic interplay. Fortunately, Picasso's exuberance of tangible expression has preserved separately for us what submerges otherwise in the flow of the creation.

It will now be evident why no simple measure can trace the development from early simplicity to final complexity. One could find a way of comparing with fair accuracy the complexity of sketch 14 with that of sketch 15 and conclude that the difference is not large since the internal intricacy of number 14 makes up for the smaller quantity of subject matter. (Compare the summary treatment of mother and child in the context of number 15 with the detailedness of number 14!) Such a comparison of successive sketches would give us essentially a measure of the complexity level at which the artist operates at the particular time—a level which is likely to be fairly constant though fluctuating. Only by selecting comparable tasks, for instance, all the attempts to sketch the total composition, could one begin to show how the complexity level of the work—as distinguished from that of the artist—rises, as it were, by accretion.

At the time sketch 1 was made, the total concept consisted essentially of four fairly simple and relatively independent elements: the upright figure of the bull, the upside-down corpse of the horse, the horizontal pointer of the light-bearing woman, and the inarticulate spread of bodies on the ground. In the later sketches, a growth of connections can be demonstrated: in number 6 the horse responds to the theme of the light; in number 10 the bull does the same and the horse now communicates with the warrior. Thus groupings begin to form; but these groups at first are as isolated as the individual figures were in the beginning. Number 12 is found to be made up of three fairly separate clusters: the bull, the horse and the warrior, the mother with her child. In number 15 a tangle of insufficiently coördinated appeals seems to fill the picture. In the early states of the mural itself, the central triangle of the victims has at first no commerce with the group of the bull. Only when the horse's head is raised and turned leftward, and when the warrior's head is made to address the bull, a connection between the two groups is established.

The formation of such relations increases the complexity of the work not only by the addition of links between the elements; these links also affect the elements themselves: they complicate the character of each of them. The separateness of each object is counteracted by its being also related to other objects, and this interplay of independence and dependence makes the nature of the subject subtler. Thus the basic detachment of the bull is eventually modified by some participation. The deadness of the warrior is relieved by his transformation into a statue, which can speak without being alive. The grief of the mother is qualified by her relationship to the bull, and the outcry of the horse acquires a connotation of appeal and expectation.

132

Refinement derives also from the multiplication of functions. In sketch 3 the figure of the horse splits up into embodiments of four different attitudes. The feminine element, at first only the light bearer, also assumes the functions of mother, fugitive, and falling victim. Further, the few and simple basic attitudes fan out into groups of phases. Thus the legs of the horse in sketch 5 depict four different stages of collapse; and the heads in the final mural display a full range of spatial orientations, from the complete upside-down position of the head of the dead child through 180 degrees to the completely erect head of the bull. Finally, one may mention the duplication of the theme of the light source, which splits up into the modest oil lamp, thrust forward passionately by the woman of Guernica, and the large, inert, mechanical luminary at the ceiling.

An increase in subtlety of meaning and richness of substance characterizes the growth of the work of art. At the same time there is constant evidence of simplification, which does not contradict the rise in complexity but is made necessary by it. I mentioned the alternation of diastolic and systolic processes; the enlargements and constrictions of the concept. Every addition, refinement, or new connection puts a strain on the unity of the work and must be met by a pulling together of the elements, a tightening of the economy, a streamlining of the over-all structure. The composition of sketch 15 furnished the most graphic example of exuberant invention, not yet subjected to the discipline of organization. The beneficial results of such discipline are shown most clearly in the consecutive elaborations of the same theme—for example, that of mother and child as it emerges in sketch 12 and is subsequently developed and simplified in sketches 13 and 14. The elements are gradually adapted to each other. They are also fitted to the main lines of the pattern and to the hierarchic scale descending from the dominant features to the most subservient ones. Sometimes greater economy was achieved in the interest of clarity by pruning and trimming. Such operations deprived the dead warrior of his torso and legs or reduced the body of the falling woman to a compact, diagonal rectangle. In both instances, the curtailment relieved the confusion of elements competing for the same spot. In both instances also, the artist was able to derive from these economy measures striking refinements of meaning.

Duplications of characters, attitudes, and sentiments were eliminated, either by removal of the duplicate—as with the dead woman in the first state of the mural, who prefigured the warrior and was superseded by him—or by assigning different functions to the duplicates and thus enriching the whole. As a result of the artist's efforts the final work presents a maximum of substance in the simplest possible form.

I have taken pains to show that formal considerations lead to solutions that are always more than formal. When an object had to be moved, the formal change entailed a change of meaning. When a foot was taken away from the falling woman and assigned to the fugitive, the result was an extension of the central compositional triangle into the right corner. This change accomplished more than the formal symmetry of the left and the right corners. It created a strong base for the leftward

133

and upward rush of the whole central group. It anchored in a cornerstone at the right the movement toward the bull, basic to the meaning of Picasso's statement; and, by reducing the area occupied by the falling woman, it reduced the catastrophe of her fall to its proper secondary status. When the bull's body was removed from the center and placed behind mother and child, the result was not simply a "compositional" improvement but a far-reaching change of meaning, which if inappropriate or senseless would have argued against the rearrangement of the shapes.

Formal resemblances invited the painter frequently to let one element of subject matter take over the function of another. But these opportunities for visual puns prevailed only when the replacement changed the meaning favorably. Thus, when in sketch 12 the tail of the bull adopted the visual function of the light bearer's arm the result impoverished the meaning, and therefore the move had to be discarded. But when the raised arm of the warrior in the first state of the mural was replaced by the raised neck and head of the horse in the fourth state, the gain in significance was such that the formal improvement passed muster.

It is for this reason that I objected earlier to the notion that creativity consists in the readiness of a nimble mind to make new combinations. Surely such flexibility is indispensable, but it is no more than a prerequisite. We observed the painter trying a given sentiment on different characters: the theme of the upward outcry was first assigned to the horse and later to the mother. A given location was filled with one character after another, and a given character moved from place to place and from sentiment to sentiment. Also, Picasso experimented with various possible groupings of characters: he paired the horse with the light bearer, the light bearer with the bull, the warrior with the horse; but these trial combinations were under the strict control of the basic vision, which used them in the search for the final form.

Visual thinking, then, was goal-directed throughout. However, the goal was neither perceptual harmony nor originality. Harmony was needed to provide the work with readable, unified sense. Originality was needed to make the work correspond exactly to the particular painter's concept and to provide it with fresh, striking expression. But, as always in the arts, beauty and originality were only means to the end of making a vision visible.

Was this vision given from the beginning? Or did it emerge only gradually? We gained the impression that the basic "mood" of the work and the main ingredients of its expression were already present when the first sketch was made. Perhaps the aggressor was in the beginning an active part of the concept of *Guernica*. Certain ambiguities in the early presentations of the bull suggest this possibility. But the aggressor was soon reduced to indirect presence by effect, and the role of the antagonist, supplementing the passivity of the victims, was assumed by the victims themselves, by the aggressive *élan* of their complaint and appeal and the challenging resistance embodied in the bull.

134

While the work was going on, there were changes of emphasis and proportion, and there were many experiments in trying to define the content by working out its

shape. A germinal idea, precise in its general tenor but unsettled in its aspects, acquired its final character by being tested against a variety of possible visual realizations. When, at the end, the artist was willing to rest his case on what his eyes and hands had arrived at, he had become able to see what he meant.

NOTES

P. 1. Paul Valéry, "Discours aux chirurgiens," *Variétés*, vol. 5, p. 53.

P. 2. *Timæus*, 71; *Phædrus*, 244–245.

P. 2. *Inferno*, canto 2, verses 7 and 8.

P. 3. Martin Heidegger, "Der Ursprung des Kunstwerkes," in *Holzwege* (Frankfurt, 1950), p. 48.

P. 4. Catherine Patrick, "Creative Thought in Poets," *Archives of Psychology*, no. 178 (New York, 1935).

P. 4. Graham Wallas, *The Art of Thought* (New York, 1921), p. 80.

P. 4. Cecil Day Lewis, *The Poetic Image* (London, 1947), chapter 3.

P. 4. J. P. Guilford, "Creative Abilities in the Arts," *Psychological Review* (1957), vol. 64, pp. 110–118. An extensive study of the creative personality has just been carried through by the Institute of Personality Assessment and Research at the University of California, Berkeley. To judge from the preliminary summaries, the results of the tests, questionnaires, and interviews will perhaps indicate which particular combinations of the ordinary personality traits are statistically correlated with creativity; but they are unlikely to tell us what creativity is and how it comes about.

P. 5. On the subject of the earth goddess, cf. Erich Neumann, *Art and the Creative Unconscious* (New York, 1959).

P. 7. Lawrence S. Kubie, *Neurotic Distortion of the Creative Process* (Lawrence, Kansas, 1958).

P. 7. Eugene Galanter and Murray Gerstenhaber, "On Thought: the Extrinsic Theory," *Psychological Review* (1956), vol. 63, p. 219.

P. 8. E. L. Thorndike, *Animal Intelligence* (New York, 1911).

P. 8. Jacques Hadamard, *The Psychology of Invention in the Mathematical Field* (Princeton, 1945), chapter 3.

P. 8. Max Wertheimer, *Productive Thinking* (New York, 1959). Karl Duncker: "On Problem-Solving," *Psychological Monographs* (1945), vol. 58, no. 270.

P. 9. Wordsworth's preface to the second edition of his *Lyrical Ballads*, quoted in *The Creative Process*, ed. Brewster Ghiselin (Berkeley and Los Angeles, 1952), p. 82.

P. 10. Jean Piaget: *La Construction du réel chez l'enfant* (Neuchatel and Paris, 1937), chapter 1. Also in English: *The Construction of Reality in the Child* (New York, 1954).

P. 11. *Inferno*, canto 26.

P. 12. For some of the formulations in the foregoing chapter I have drawn on my article, "A Psychologist Looks at Inspiration," *Art News* (1957), no. 4, pp. 31–33.

P. 13. Alexander Liberman, *The Artist in His Studio* (New York, 1960), p. 33.

P. 14. For some reason the Spanish name "Guernica" is almost universally mispronounced. The stress should be on the second syllable and the "u" not sounded.

P. 14. The *Guernica* sketches were first published in the year they were done—that is, in 1937—by *Cahiers d'Art* in Paris. They were reproduced again in 1947 in the book *Guernica: Pablo Picasso*, published by Curt Valentin in New York with text by Juan Larrea and an introduction by Alfred H. Barr, Jr. The material for the murals *War* and *Peace* is available in *Picasso, la guerre et la paix*, Editions Cercle d'Art (Paris, 1952).

P. 15. Misjudgment of the reality level of a painting will necessarily lead to a misinterpretation of the work itself. See, for example, Vernon Clark's article "The Guernica Mural: Picasso and Social Protest," in *Science and Society* (1941), vol. 5, pp. 72 ff.

P. 16. Herbert Read, "The Dynamics of Art," *Eranos Jahrbuch* XXI (1953), pp. 272 ff.

P. 16. The analogous search for the appropriate level of abstraction in poetry is illustrated by the worksheets of poets in my "Psychological Notes on the Poetical Process," *Poets at Work*, edited by Charles D. Abbott (New York, 1948). The same essay describes "typical early stages of organization in which motifs appear which 'belong' to the central theme of the poem but are not yet clarified as to the specific place and function they are to assume within the whole and with regard to other elements of the structure. One can observe them floating in the space of the poem, tentatively anchored here and there, changing their syntactic connection with other motifs, assuming a leading role at one moment and being demoted to the ranks in the next" (p. 160). This is exactly what will be shown to have occurred during the preparation of *Guernica* also.

P. 17. Daniel E. Schneider, *The Psychoanalyst and the Artist* (New York, 1950), p. 216.

P. 17. Lionel Goitein, *Art and the Unconscious* (New York, 1948), item 10.

P. 18. Various authors give different dates for the bombing of Guernica, although April 28, 1937—a wrong date— is mentioned most often. There is some confusion also in the primary sources; they agree, however, that the attack took place on a Monday, the weekly market day, on which the town was crowded. This confirms the date as Monday, April 26, 1937. Cf. Hugh Thomas, *The Spanish Civil War* (New York, 1961), p. 418.

P. 18. Some documentary photographs from the Spanish Civil War as well as of pertinent newspaper clippings—among them the *Times* (London) report of April 27—are contained in the useful catalogue *Guernica* published by the Stockholm National Museum in 1956 in occasion of an exhibition of the mural and the preparatory sketches. The booklet is distributed in the United States by Wittenborn, New York.

P. 22. Compare here my comment on two Picasso "monsters" in *Art and Visual Perception* (Berkeley and Los Angeles, 1954), p. 132.

P. 22. Vicente Marrero, *Picasso and the Bull* (Chicago, 1956).

P. 23. Picasso has expressed himself briefly and equivocally on the subject of the bull. Shortly after the liberation of Paris an American painter, Jerome Seckler, then in the army, called on Picasso and presented him during the conversation with his own interpretation of the symbolism of the bull in *Guernica* and in the *Still Life with a Bull's Head* of 1938. Picasso denied that the bull stood for fascism but was willing to concede that he represented "brutality and darkness." In order to clarify the matter, Alfred H. Barr asked Daniel-Henry Kahnweiler to question the painter, who replied: "The bull is a bull and the horse is a horse. These are animals, massacred animals. That's all, so far as I am concerned!" See Barr's *Picasso: Fifty Years of His Art* (New York, 1946), pp. 202, 217, 247, 264, 265, 268, as well as the symposium on *Guernica* which was held at the Museum of Modern Art on November 25, 1947, and of which a transcript is available in the library of the Museum.

Students of astrology may be interested to note that, as Miss Dolores Leviker has pointed out to me, the bombing of Guernica and much of Picasso's work on the mural took place during the month ruled by the zodiacal sign of the Bull (Taurus).

P. 23. As an illustration of what can happen when the pictorial image is used as a springboard for the private fantasies of an author, I quote from a film script on Picasso's *Guernica* by Sidney Janis, commentary by Harriet Janis, in the *Pacific Art Review* (1941/42), vol. 1, nos. 3–4: "The bull is momentarily resting after spending himself in fierce exertion. Still palpitating from the orgy he has just been through, he is being incited to further lust by the screams of the mother. His eyes are keyed to her cries, his tail bristles. He has turned about, ready for a renewed charge."

P. 24. Bertolt Brecht, *Schriften zum Theater* (Berlin and Frankfurt, 1957), p. 19.

P. 25. Strictly speaking, *Guernica* is not a monochrome. In certain areas of the picture the canvas, not covered by paint or only lightly so, contributes shades of a rose color, which makes some of the gray tones of

the paint look bluish. This produces a lively variety of delicate hues.

P. 26. Statement by José Luis Sert at the above-cited symposium. A photograph of the Spanish Pavilion can be found in Larrea, *op. cit.*, p. 26.

P. 27. On the compositional function of left and right see the literature given in my *Art and Visual Perception*, pp. 18, 19, 378, and more recently Kurt Badt, "*Modell und Maler*" *von Vermeer* (Cologne, 1961).

P. 28. *The Sculptor's Studio: Etchings by Picasso*, with an introduction by William S. Liebermann (New York, 1952). Cf. Paul M. Laporte, "Picasso's Portrait of the Artist," *Centennial Review* (1961), vol. 5, no. 3.

P. 30. Quoted from Alfred H. Barr, Jr., *Picasso: Forty Years of His Art* (New York, 1939), p. 15.

P. 68. Quoted from Barr, *ibid.*, p. 13.

P. 84. For the perceptual expression of the *magatama* see my article, "Perceptual Analysis of a Cosmological Symbol," *Journal of Aesthetics and Art Criticism* (1961), vol. 19, pp. 389–399.

ACKNOWLEDGMENTS

I am grateful to Mr. Pablo Picasso for his permission to reproduce the *Guernica* material in this book. The photographs were supplied by the Museum of Modern Art in New York and are used here by permission of the Museum, which houses the originals of the sketches on an extended loan from the artist. I wish also to thank the members of the Museum staff for their generous and patient assistance in the preparation of the book.